CRITS
A Student Manual

Terry Barrett

BLOOMSBURY VISUAL ARTS
LONDON · NEW YORK · OXFORD · NEW DELHI · SYDNEY

BLOOMSBURY VISUAL ARTS
Bloomsbury Publishing Plc
50 Bedford Square, London, WC1B 3DP, UK
1385 Broadway, New York, NY 10018, USA

BLOOMSBURY, BLOOMSBURY VISUAL ARTS and the Diana logo are
trademarks of Bloomsbury Publishing Plc

First published in Great Britain 2019

Cover design by Irene Martinez Costa
Cover image © Alma Haser / Getty Images

Bloomsbury Publishing Plc does not have any control over, or responsibility for,
any third-party websites referred to or in this book. All internet addresses given in
this book were correct at the time of going to press. The author and publisher
regret any inconvenience caused if addresses have changed or sites have
ceased to exist, but can accept no responsibility for any such changes.

A catalogue record for this book is available from the British Library.

A catalog record for this book is available from the Library of Congress.

ISBN: HB: 978-1-3500-4159-2
 PB: 978-1-3500-4158-5
 ePDF: 978-1-3500-4160-8
 eBook: 978-1-3500-4161-5

Typeset by RefineCatch Limited, Bungay, Suffolk
Printed and bound in India

To find out more about our authors and books visit www.bloomsbury.com
and sign up for our newsletters.

For Emma, Vivian, Tess, John Peter, Liam,
Juliet, Benjamin, Dylan, and Gavin

Contents

Preface

This book is written on the basis of many years of teaching about art at the college level. It is written to improve studio critiques, basic instructional devices that are used throughout higher education in studio art courses, which are examined less often and less thoroughly than they ought to be. *CRITS* is written for students and directly addresses them with the hope that it can enhance their educations in art, and their lives, during and after their formal studies. The book is optimistic and hopeful.

Thanks to all the students and faculty members who have directly and indirectly contributed to this book by participating in classes, workshops, and critiques that the author has offered over the years at (in alphabetical order) Alderson Broaddus College; American Photography Institute; Amsterdam University of the Arts, the Netherlands; Art Academy of Cincinnati; Arizona State University; Austin Peay State University; Ball State University; Boise State University; Colorado State University; College for Creative Studies, Detroit; Cranbrook School of Art; Culinary Institute of Chicago; Eastern Michigan University; Higher Institute for Fine Arts (HISK), Antwerp, Belgium; George Mason

University; Goshen College; James Madison University; Kenyon College; Kutztown University; Miami University, Ohio; Moore College of Art and Design; Mount Mary College; National Yunlin University of Science and Technology, Yunlin, Taiwan; Netherlands Academy of Film and Television, Amsterdam; Northern Illinois University; Nova Scotia School of Art and Design; Ohio State University; Old Dominion University; Otterbein College; Palm Beach Community College; Penn State University; Portland Community College, Oregon; Pratt School of Art and Design; Rhode Island School of Art and Design; Redeemer University College, Waterloo, Canada; Rocky Mountain College; Salamanca University, Spain; Savannah School of Art and Design; School of the Art Institute of Chicago; Southern Connecticut State University; Southern Illinois University at Carbondale; The Tehran Museum of Contemporary Art, Iran; Texas Christian University; Texas Woman's University; Three Shadows Art Centre, Beijing, China; University of Alaska, Anchorage; The University of Arizona; The University of Central Arkansas; University of Florida; University of Georgia; University of Kansas; University of Memphis; University of Michigan; University of New Mexico; The University of New South Wales, Australia; University of North Texas; University of Northern Arizona; The University of Northern Iowa; University of Oregon; University of St. Louis; University of Texas; University of Toledo; University of West Virginia; University of Wisconsin Milwaukee; Virginia Center for Contemporary Art; Vrije Universiteit Brussels, Belgium; Webster University, St. Louis; Western Michigan University; and the Wexner Center for the Arts, Columbus, Ohio.

Thanks to supportive colleagues and friends who helped with this manuscript, including Liora Bresler, Laura Evans, Brent Hirak, Andi Larsen, Georg Heimdal, Karen Sam Norgard, Peter Chan, EunSook Kwon, and former students at The Ohio State University and the University of North Texas.

Thanks especially to my wife Susan Michael Barrett who has read and reread every iteration of each sentence I wrote and then revised, offering her insights with love, enthusiasm, joy, deep spirit, and discerning mind.

Thanks to the reviewers of the manuscript: . . .

Thanks to Bloomsbury editors and designers: . . .

Introduction

In college studio courses in any medium and at every level, critiques, occasions in which you talk about art that you and others are making, are an important means for learning about art. The purpose of this book, a student manual, is to increase opportunities for you to learn more about art through studio critiques in design and art-making courses. Most studio courses rely in part on critiques as a means of teaching and learning. Many professionally mature and economically successful artists and designers continue to seek critiques on their own throughout their careers.

The primary purpose of participating in critiques is to learn about objects and their making and how they affect their viewers and users. However, this book has secondary goals of learning about yourself and others through critiques, and to develop responsiveness to others through the works they produce. Although these goals are secondary, in the scheme of life they may be the more important.

Learning about art

Throughout this book the term 'art' refers to all objects and events made within art and design courses across all disciplines. This use of 'art' is meant to negate any presumptions of a hierarchy of values pertaining to arts, crafts, design, illustration, performance, video, photography, and any other media.

Critiques are a readily available means of learning about your own art and the art of others. Critiques provide you with chances to show your work and to receive comments about it from instructors and peers in art classes or from friends within and outside of the studio classroom. By seeking critiques of your work you will lessen the chances of working in an intellectual and emotional vacuum. You can find out what others see in your work, or fail to see. You can learn how others interpret what your work means to them. You can learn about thoughts and emotions that your work elicits. You can learn about what appeals to others in your work and aspects that they may not understand or appreciate. All responses to your work can be valuable opportunities for you to learn more about it and how it affects those who see it.

Learning about yourself

Actively engaging in or observing critiques will provide you with multiple and multifaceted opportunities to better know yourself. You will be able to learn about what you value in works of art that you and others make. You will learn what you do and do not prefer in art. Based on your preferential reactions to your own

work and that of others, you will have opportunities to define or refine what is most important to you as an artist or designer. You can also learn what motivates you to make things, and what you might need to continue making things, even in the face of difficulty and discouragement.

In critiques while learning about art through its sensual qualities, you can also learn about your abilities to express yourself in words, both spoken and written. You will have opportunities to develop your expressive skills in speaking and writing, in addition to developing as a visually expressive and communicative person.

Perhaps as important as gaining knowledge about yourself, by actively participating in critiques, you will have opportunities to observe yourself in relation to others. You can reflect on what you say, how you say it, and by observing the reactions of those who hear you, you can gain insights into how your words and manners might be affecting others. You will have opportunities to reflect on how you listen and occasions to develop your ability to see from another's perspective. You will have frequent opportunities to be reflective about how you respond to comments from others about your work. Those comments will often be complimentary but not always. How do you respond inwardly to yourself and outwardly to others when your work is said to be lacking in effort or effect? How will you successfully handle possible discomfort in disagreement about how others perceive and value your work? How do you speak to others about their work?

Critiques will also provide you practice to say what you want to say in a way that can be heard. You can reflect on the sound of

your voice when you speak, listening for unintended edges and patronizing tones or attentive interest and curiosity. You will also have occasions to practice saying what you think and believe without being unnecessarily aggressive or hurtful.

Learning about others

By thoughtfully and reflectively participating, listening, and observing during critiques, you will have opportunities to learn about others through the works that they make. You will also have occasions to learn about others through seeing and hearing how they react to the work that you make. Topics for discovery include similarities and differences of values that people hold toward life as revealed through art and design.

Learning about others and how to interact effectively with them is crucial to practicing artists and designers. Designers necessarily design to meet the needs of imagined or actual clients. Artists, unless they choose to work in hermetically sealed studios and never show their work, are also dependent on people for support of their work.

Becoming independent and self-motivated

All art instruction, and particularly critiques, can tempt you to become overly and unhealthily dependent on the views of your art instructors and respected peers. Upon reflection you may find yourself trying first to please instructors and fellow students

with your work rather than developing an independent spirit that can thrive without being overly dependent on the views of others. One day you will no longer be in school and no longer have instructors providing you with assignments or motivation to work. A crucial test of all artists is whether they have whatever it takes to keep on making art.

Sources of the book

This book is informed by both theory and practice. Regarding theory, the theoretical underpinnings of *CRITS* are articulated in my earlier books and articles,[1] which are informed by the writings of philosophers, art critics, historians, and artists. Regarding practice, all of the activities recommended in this book have been tried in actual teaching situations at a wide range of institutions identified in the Preface. Each activity or strategy has been modified based on actual experiences during a fifty-year time span as a professor within colleges of art. In this book, students and instructors have contributed their narratives about critiques in their lives, their remembered experiences, and their suggestions to improve critiques. The book is informed by and meant to benefit students in any visual arts media, beginning to advanced, undergraduate and graduate, majors and non-majors.

The data for this book are gathered by means of qualitative methods as a participant-observer of critiques in undergraduate and graduate art programs, a facilitator of group discussions in art museums, open-ended interviews with students and

[1] See Barrett entries in References section at the back of this book

instructors, surveys, and personal communication with artists and art critics about critiques.

Assumptions of the book

Implicit and sometimes explicit assumptions throughout the book include the following:

- Optimism is a choice and this book is optimistic about the present and the future of art and society.

- Artists and artworks benefit from communal interactions among artists through critiques.

- Cooperative learning is favored over competitive learning.

- Art is a unique form of knowing and expressing: without art we would know less, differently, and in impoverished ways.

- It is a positive value that all learners, especially art students, become independent of their instructors and classmates while also learning from them.

- Critiques are living occasions that continually change forms and accordingly affect different outcomes.

- All education is toward change, particularly education in art, which purposely and productively resists fixed definitions of both art and critiques.

- To change oneself is to change society.

The logic of the book

The book begins with stories of critiques told by students engaged in them long ago and recently. The stories are both positive and negative about what worked well and why and about what did not work well at all. The stories provide some real life contextual information for all that follows in the book. The positive stories are offered as encouragement and the negative stories are presented as challenges to improve how we interact with one another in critiques.

In Chapter 2, definitions of critiques follow the student narratives about critiques. Although common in art instruction, critiques are an open and evolving means of teaching and learning that do not have a single, agreed upon definition. A variety of instructors offer their individual notions of critiques and thus allow new flexibility in what critiques are and how different they could be.

Chapter 3 presents the views of students and instructors on how they would like critiques to be and what they want to avoid in critiques. Students and instructors tell what works for them, how, and why, and also what does not work. There is much consensus about what students and instructors each want in critiques, and this is cause for optimism. When instructors and students agree on what they would like to have happen in critiques, it then remains how to successfully conduct and engage in critiques.

Critiques are a form of communication. Critiques occur on a one-to-one basis and as group discussions. Chapter 4 offers

practical suggestions for effective communication. The suggestions are rooted in communication theory and have been tested in practice. Good communication is important for critiques and all aspects of communal living in and beyond art classes.

Chapters 5, 6, and 7 explore actual and potential content for critiques. The chapters answer questions of what you can do during critiques. You can do any and all of the processes of describing what you see or experience, interpreting the thoughts and feelings you associate with the artworks you are examining, and form carefully considered value judgments about how well those artworks work, or do not.

The final chapter offers ways and means and examples of how you can write about yourself and your work in the form of artist biographies and artist statements. Exhibition venues, competitions, granting agencies, and schools of art request such writings. Importantly, occasions to write about yourself as an artist and why you make art provide you with opportunities to better know yourself and your art, and to be better able to articulate what you are about as a contributing member of society.

1

Definitions and stories

Critiques are common in art courses and instructors say they are a necessary part of teaching art at the college level, but surprisingly, there is no single accepted definition of what a critique is. This chapter first offers different ways that art instructors define critiques. Following these definitional considerations, art students offer narratives of actual critiques they have been part of, for better and for worse, in the past and recently.

"Critique," "criticism," and "art criticism"

A lack of a set definition of a critique is viewed here as a good thing. Critiques are living phenomena that change according to who participates in them, where, and why. Critiques change over time. This book is not an attempt to find or formulate a fixed

definition of a critique. However, the book is dedicated to identifying and promoting best practices and eliminating those that are not beneficial.

In ordinary English the term "critique" is both a noun and a verb. As a noun, in general usage, "critique" refers to "a detailed analysis and assessment of something, especially a literary, philosophical, or political theory" as in the phrase "a feminist critique of objectivity."[1] As a verb, "to critique" is to offer such an analysis, commonly in written form. The term "criticism" in ordinary language is defined as "the expression of disapproval of someone or something on the basis of perceived faults or mistakes."[2] In ordinary language, "to criticize" is to indicate faults in a disapproving way.

Consequently, unfortunately, and unavoidably, people commonly associate terms like an "art critique" and "art criticism" with the negative connotations of finding fault that derive from daily usage of "criticism." However, neither term "art critique" or "art criticism" necessarily denotes negativity: Critiques and art criticism are occasions for contemplation and commentary.

Common notions of studio critiques and art criticism are also intermingled in ways that cause confusion for art students as well as the general public. Art criticism and critiques are significantly different. Art criticism is writing about art for a

[1] English Oxford Living Dictionaries (2017) https://en.oxforddictionaries.com/definition/critique (accessed 18 July 2017).

[2] English Oxford Living Dictionaries.

public audience, such as the readers of the *New York Times* or a blog.[3] Published art criticism has been carefully considered, written, revised, and edited by a publisher. Art critics do not write articles for an artist who made the work, they write for a larger public audience. Criticism is not written to help an artist make better work, it is written to inform interested readers. Contrary to popular belief, art criticism is more often positive than negative. Critiques, however, are discussions for the benefit of a student artist and classmates. Studio critiques are for those participating in them and not for the public. They are usually oral rather than written. They are spontaneous and unedited. They are usually motivated by a desire to have art made better and are often in the form of advice giving and instruction.[4]

Different critiques for different levels

Different kinds of students with different levels of experience participate in critiques including: general education students who take art courses for their personal enrichment with no intentions of majoring in art or becoming professional artists, art students fresh out of high school art classes, advanced undergraduate art majors, students who are advanced in a specific medium but are

[3] Jane, J. (2017), 5 NYC Art Blogs You Should Be Reading, Huff Post, https://www.huffingtonpost.com/2013/09/26/nyc-art-bloggers–5-blogs-_n_3997011.html (accessed 28 December 2017).
[4] For a more thorough discussion of 'art criticism' see Terry Barrett (2011), Chapter 1, "About Art Criticism," *Criticizing Art: Understanding the Contemporary*, New York: McGraw-Hill.

taking a level-one course in a medium new to them, and students beginning or completing Master of Fine Arts degrees. Some students are there to become knowledgeable and skilled art teachers rather than professional artists.

Students participating in critiques have varying degrees of knowledge of art history and art theory; some may only be familiar with Western art history, and others will never have heard of Postmodernism. Presumably, all will be welcome in any critique: Everyone has a different perspective that can add to the conversation. Presumably, instructors will facilitate critiques in varied ways to meet the differentiated needs of those taking part in a critique.

Critiques and judgment

All of the instructors surveyed for this book agree that judgments are important to critiques, and some maintain that they are essential: "A critique is an examination of a work of art to determine how successful it is." Another instructor says that a critique is "an on-site, at-the-moment, in-person evaluation of students' artworks," and a third instructor specifies that a critique is "a verbal evaluation done in the form of a dialogue about student work." A fourth instructor adds that a critique is a "co-evaluation" with the student and instructor to judge how successful a student's work of art is.

On what basis will success be determined? Two instructors specify that success is based on "the objectives of the assignment"

or "goals and guidelines previously established." These two assertions situate the critique as fulfilling goals and objectives set by an instructor, and this may often be the case in introductory courses or in initial explorations of a new medium or idea. Eventually the problem of establishing goals for your work will be yours.

Although some situate the critique between instructor and student another instructor invites commentary by many viewers: "an event during which the artist finds out viewers' responses." A different instructor defines a critique as "an opportunity for artists to solicit informed opinions regarding their work." There is an invitation here for you to ask for critiques when you want them. In addition to inviting or requiring commentary from more viewers than the instructor only, this definition identifies an important criterion about opinions, namely, that they be informed. The implications of the statement are that comments about art are opinions, but that some opinions are informed and others are not, or that some opinions are better informed than others, and thus ought to carry more significance.

The specification for informed opinions asks you to weigh the statements you make: Is your comment merely idiosyncratic and based only on your personal preferences, or is it informed by knowledge of art and the world? The criterion also disallows you from dismissing someone's comments by saying or thinking, "Oh, that's just your opinion." If the opinion is informed it deserves your consideration.

Additionally, a critique is an event during which the artist finds out viewers' responses "so that the artist can evaluate how

the image is interpreted and judged by others." That is, when hearing commentary on your work, you can decipher the informed from the uninformed, and even when commentary is informed, you still get to decide whether and how you will further consider it or if you will act upon it.

Critiques and interpretation

Some instructors shift emphases away from explicit judgments of success or failure, away from questions of how good the work is, toward topics of interpretation, namely, what the work is about and what it expresses. Three instructors define critiques with interpretation being central: 1) a critique is "a conversation about why and how a work of art was conceived and created," 2) "an opportunity for students to get guidance and support from faculty and peers to gain greater consciousness of the 'hows and whys' of their works," and 3) "the best opportunity for students to receive public reactions to their work. They can find out how their art is perceived by other students, and the faculty member can gain insight to the thought processes behind the student's creation."

One instructor sees a critique as "an occasion for students to develop a critical awareness of their own work, or one might say the ability to step outside their own subjectivity regarding the work, and gain some idea of how the work relates to contemporary art." A different instructor wants to use critiques as "a means for a group to get at big issues" outside of ideas about art itself to

ideas about the world we live in. This instructor also wants critiques "to form a bond of purpose for a class," bringing them to realize they have a commonly shared purpose that encourages cooperative rather than competitive artmaking and learning.

Knowing your intent in making a work, or learning about what your work expresses to others, is not an end point. It is a beginning for you to explore whether your intentions are actually realized in the finished work. Consequential questions then arise: Is your intent itself worthy? Might the artwork express more or differently than what you intended? If so then what? If you or another artist intends one thing but achieves a different thing, does that make the artwork unsuccessful? Upon examining your work during critiques through questions of interpretation about meaning and expression, you may decide to alter your work to more closely reveal what you intend the work to express. It may be not be about changing your work but shifting your thinking about it because of what you are able to learn from others about your work.

Some conclusions about defining critiques

We can draw some conclusions from these definitions about critiques offered by instructors who are actively engaged in and concerned about teaching art. Perhaps most importantly, none of the instructors dismissed critiques as trivial or a waste of time. While all the instructors think critiques are important, none of

them appeal to a universally agreed upon definition of what a studio critique is or should be.

Critiques are live and organic events among students and instructors. Critiques are "out-loud" rather than silent internal discussions. They involve someone in addition to the artist, often an instructor and a group of peers. They provide opportunities for you to learn more about art, yourself, and your fellow artists.

Most of the definitions specify that critiques are and should be occasions to measure success or lack of it in art making. Many definitions emphasize discussions of artists' expressive and ideational intentions in making work, asking you to consider both intentions in themselves and intentions as they are revealed to others in your work. Sometimes critiques invite and foster discussions larger than the work itself. Critiques can serve to bond you with other students to work together as a purposeful and cooperative group.

This book is in consort with the instructors quoted above, especially with those who stress objectives that go beyond the judgment of the success of artworks and that embrace larger issues than the immediate artwork in question. The following section considers what students said have happened in critiques, regardless of how critiques may have been defined.

Stories about critiques

The following are narratives written over a span of twenty-five years collected from art students in response to two questions:

"What was your worst critique?" and "What was your best critique?" Some of the narratives are people's recollections from many years ago, and others are recent. For those who tell the tales, their experiences of critiques are vivid, some lasting many years after their occurrences, reminding us that critiques can be powerful.

Some occurrences in critiques as told by students are baffling. One student wrote, "I was a sophomore in a painting class and made a landscape and the instructor looked at it and laughed at me, long, with no comment, and shook his head and walked away." Another wrote, "In a freshman design class (2015), a professor very briefly examined several pieces and just said, 'Oh Jesus', and walked away."

In these two brief accounts, we only hear from the students, not from the instructors. It would be informative to know what the instructors were thinking when they made these comments and what they hoped to accomplish by saying them. We will never know. Perhaps the instructors were overwhelmed with the thought of how much they might have to teach if their students were to make the kind of work the instructors valued. Also, in these brief accounts, the students who tell their stories only imply their reactions as if their thoughts and feelings were self-evident. Further explanation from both instructors and students would be beneficial in understanding both.

Students have options of how to react in the moment or after some thought: perhaps they could note that the work they were showing seemed to be far removed from what the instructor would be expecting in the course. They could have heard the

comments as motivating challenges. When you face statements you find harsh you can turn them into positive considerations.

Sometimes, in poorly facilitated critiques, fellow students can be mean:

> My worst critique was during the summer of 2012 when I took figure drawing as a five-week course. Our final project was a self-portrait. We did a group critique and my classmates picked my work apart pretty viciously. They told me it looked silly and childish, but not in a good way: "Your background looks like a bunch of Skittles" and "It's like a bad Dr. Seuss book." It wasn't just me that got a negative critique, a lot of other people did too. Comments were just thrown around with no follow-up. It seemed whatever random thoughts came into people's heads were spoken just for the sake of saying them and getting credit for participation.

If such an occurrence arises in a critique in which you are participating, and you are troubled by it, you might say something to change the direction, perhaps simply by saying aloud that you are uncomfortable with the tone of the discussion. Perhaps your comment will have a positive effect and cause change and if it does not, you have at least honored your beliefs.

Some instructors tend to rely on negative reprimands rather than positive reinforcements as a means of teaching: "I had an instructor in Design II (2014) who wanted us to focus only on the negatives and improvements that could be made to the pieces." How will you respond if you hear only negative things about your work?

In a different critique situation, a student recalls this: "mid-freshman year (1997), all the professors sat us down with our best pieces. Their goal seemed to be to demoralize every one of us so they could mold us into their idea of artists." We do not know what the instructors actually had as their goal but it is likely that they wanted the students to improve their work. We do know that the student had to work on not being demoralized. How will you react to comments so that you will not become demoralized?

One student, reflecting on the past, now realizes the amount of anxiety critiques gave rise to: "I think whether bad critiques actually occur, there is an enormous amount of anxiety around and vulnerability embedded in those experiences. I had taken art ever since elementary school and was in Advanced Placement art in high school, and I cannot recall a bad crit in college, which is odd because I left studio in 1997 and switched from Art to Art History because of my fear of critiques." Now, some twenty years later, this person is a happily active art professional but works neither in art or art history. This anecdote is not to suggest that critiques need be stressful or that you change majors if they are, but to realize that you can be reflective, flexible, and adaptable by making adjustments that suit you.

Controlling access

In the past, some art instructors viewed themselves as the persons to control access to an area of study, and sometimes instructors were requested to do so by their departments. Some courses

were designed to identify students who were considered likely to succeed from those who were not. Critiques in these courses may have been particularly difficult to experience. One student recounts this experience: "The critique I remember most from college (1980s) was when the teacher made a girl cry by telling her in front of the class that her work was awful and that she should drop out of art and become a business major." A different student in another program wrote: "I was a sophomore and had about ten faculty members look over my portfolio. The head of the Graphics Department totally embarrassed me by announcing how bad an artist she thought I was. Then she asked me what made me believe I could be one. I did not have much to say as the tears started to roll."

These hurtful instructors were likely well intentioned, thinking they would be saving some students hours of course work and money spent on tuition by directing them elsewhere in college and in life. A problem with such interactions is that some students who are steered away may become successful majors in other areas but may also end up avoiding future art experiences and relinquish artmaking altogether. This is an unfortunate and unnecessary outcome for all, and especially for those taking art courses for enrichment or to enhance another area of study.

Altering students' work

During drawing classes, some instructors physically altered students' artworks without the students' consent. One student

recounts, "I had a teacher (1970s) who used to walk by and put a line through your figure drawing if he didn't like it." A different student in a different school wrote, "When I was a freshman in a life drawing class (1996), the teacher took a student's drawing and stepped all over it." Another student in a different school reported that, "When I was a junior in a drawing class, a teacher said that my still life was not to her liking, and she sat in my chair, erased my entire drawing, and redrew it to her liking and told me that is how to draw a still life."

Students recalled similar incidents in painting classes. One wrote: "When I was a freshman in a painting course (1993) my instructor grabbed my palette full of different colored paints and smashed it against my finished painting saying it was not what he wanted." A photography student at a different school wrote:

> Photography critiques (1979) were held in a long, empty room with a single rail running the length of it, and a window at the far end. Students brought in two or three of their best works, which were matted, and placed them upright on the floor along the railing. We waited, leaning against the opposite wall. The professor would enter the room, walk back and forth to scan the photos, and select about a dozen, placing them on the rail. After he made his selection, he nodded to one of the TAs who then gathered up the photos remaining on the floor. Another TA opened the window, and the TA ceremoniously dropped the work out of the window onto the parking lot below.

A different student recalls:

A teacher (1991) tore someone's freshman 3D design project in half and took another student's project and opened up the window and threw it out. He said, "I think this would look really great in the air--flying--yes!" The kid was really upset. Also, that teacher ran over someone's project with a car. (This teacher was crazy, I think.)

Some students in ceramics classes told somewhat similar stories: "During critiques in a pottery class at a university in Louisiana in 1972, the professor would break the pots he didn't want to fire. There was no discussion." A ceramic student at a different school recalled, "We had a critique about once a month. The professor would walk through, break everything he disliked, then what was left, we critiqued."

Fortunately, such occurrences are less often told today than in the past. However, one possible lesson to be garnered from such narratives is to realize that instructors may want you to value the process of making work as more important than the actual objects that you make.

Clashes over style and content

Students have experienced conflicts over their style of making work that does not match the instructor's. One student wrote:

As an undergrad in a drawing class in a large Midwestern state university in 1968, I became disgusted with the prof's requirement that we draw like he drew. He never said that

mimicry was a requirement but during his critiques of my work he told me that my drawing was not well developed and needed work. I knew that I drew well so I decided to do an experiment prior to the next critique. The crits were spontaneous, and held at our individual drawing horses in the company of the rest of the class. So, I drew just like him. He praised my drawing, told me that it flowed, was expressive and well composed. Additionally he liked the way that I used the pencil with firm and light pressure to achieve varied results. When he said that he liked my drawing and showed his ebullience I told him that I was glad that he liked it because it was *his*. That is, it was drawn intentionally the way I thought that he would draw it with no effort toward delivering my own style. He stormed out of the classroom. In his absence, other students told me that they agreed with me and that they too were tired of tailoring their drawings to meet his narrowly prescribed preferences. After about 20 minutes the prof returned and apologized to me, and told me that although I angered him he got my point.

In retrospect, the student realized that the outcome was "a mixed blessing because the remainder of the semester was stressful, and the instructor just let me draw as I chose to with little further input from him."

Other conflicts have arisen over students' choices of content for their artworks that do not meet the unstated expectations of instructors:

For my first college studio art class at an Ivy League university in the 1990s, I made a nine-panel charcoal, pastel, and

watercolor painting/drawing with a poem/text as an integral part of it. Of course, I had worked very hard and was nervous about art class, (I was a theatre and journalism kid), and when I lugged it in and hung it up on the wall, I was shaking like a leaf. The art professor took one look at it (it was, actually, huge; nine 18″ x 24″ panels) and said: "I hope this isn't an illustration to a favorite rock song."

The student had written the poetry and took the instructor's comments to be a "cynical put-down."

A different student wrote about a disturbing critique in an introduction to printmaking class in 2015: "In our second critique the professor said half of the pieces looked like 'shit', and that our content was not something he 'liked', although he told us at the beginning of the class to do something that is important to us and no one else."

These specific narratives are not meant to suggest that students are not open to negative responses to their work. Rather, it seems that they want to understand the reasons for negative appraisals. For example, one student expressed appreciation for a negative critique: "When I was a junior in figure drawing (1997) my teacher told me my final drawings were some of the worst work I had done all semester. He explained why they were bad, how I could have gone about it to make them better."

Issues around gender, race, and religion

Content issues arise over conflicting beliefs and biases among some instructors and some of their students. One male student

recounts interactions with an instructor who considered herself to be a feminist: "When I was a sophomore in a photography class (1995) each and every critique was painful to sit through. Myself and three other male students were subjected to being called pigs, sexual deviants, rapists, and other assorted names."

A female student recalls troubles with her male instructor in Thessaloniki, Greece in the 1990s: "I faced prejudices against women artists. Often the college teacher preferred not to advise me and other girls. Instead, he preferred discussions with the boys. He strongly believed that 99 percent of women would quit their artistic careers."

Regarding race, a student recounts this: "In a first year graduate photo studio (1999), my white male professor told me 'we' were beyond the issues of identity in gender and race that I was exploring in my work. He then proceeded to tell me that women and people of color have made great progress over the years." Another student of color wrote this:

Most of the time my work gets misinterpreted solely on the fact that I have skin color. If I were to submit the work anonymously to an exhibition, color wouldn't be an issue purely because I am a minority. It's extremely frustrating when all people see of my work is a color and nothing else for no other reason than my skin tone. It's like a different version of racism where your work is scaled down and denied its true meaning and labeled a color.

From these accounts we can listen to these two students with empathy and think more carefully about how we might be

responding to work. Some artists of color do not want to be identified as such, while others do. Some artists want to be known as an "artist" rather than as a "black artist" or a "black woman artist." Open dialogue with your peers can alleviate some of the potential problems of how we identify others regarding race and gender. A general recommendation is to let people self-identify and then respect their wishes.

Regarding religion, a different student recalled this experience in junior year during a sculpture critique in 2016:

> Most of my work has a religious undertone but is not overtly religious. Being in a very liberal environment, I'm used to some backlash. My class knew from past projects that my pieces were religious and that my teacher was an atheist so they tore apart my project, nit picking on anything they could find. Nothing was constructive.

The narrator assumes bad intent on the part of the instructor because of known or perceived differences about beliefs and suggests that classmates ganged up accordingly. Perhaps the student's assessments are accurate. A reminder: Acting on beliefs has consequences, especially if your beliefs are a minority position in any particular context. You have choices, one of which is to express your beliefs and accept any consequences; another is to hold your beliefs quietly in certain situations and express them elsewhere. You get to decide.

The student's real or assumed problem with expressing religious beliefs in a secular art room is similar to dilemmas artists face with other choices: Should you continue to make

representational art if an educational environment fosters abstraction? Andrew Wyeth did not fare well in the artworld during his lifetime because he was a realist among Abstract Expressionists. If minimalism is the valued way to make art in your school, should you pursue your desire to work differently? These are difficult choices for you to make.

Based on these narratives of experiences students found negative do not be misled to believe that students only want to hear good things about their work. One student wrote this story:

> The best critique was the end of a drawing class freshman year (2013). The instructor knew how to throw down a good old-fashioned critique. She wanted truth, honesty, and tears to roll. Not because she was wicked but because she was raw and wanted to cultivate true talent. She could see that I had a thick skin and that I valued critique the same way she did–as a way to grow and also to help guide people out of the program. For me, the truth is that many of these people who dropped art majors eventually found their calling somewhere else. To give them false hope is to waste their time and money. So, giving them an honest critique should be a courtesy. By the end of the semester, everyone finally felt comfortable "going there." I remember there was a lot of teary eyes and slouched people. Many of my classmates admitted they were going to drop the program and pursue something else. Some students said they "thought they were a better artist than they actually were." I am no Rembrandt but this allowed me that critical moment

in my growth as an artist. It was the moment where I knew that I was born to do this. That critique set me off in the best direction.

Many students express gratitude when, on the basis of critiques, they learn how and where their works may have fallen short. "One of my biggest pet peeves about critiques in most studio classes I have taken is that most students got a lot of compliments but nothing constructive to help them improve (2016)."

A different student reminds us that students can directly change the direction of a critique:

One of the best crits that sticks out was in a 3-D design course (2013). One of my classmates stopped the crit and made the point that he had been getting lots of "I like" comments. He said, "Listen, it doesn't really matter what any of us like. Let's talk about what the assignment was and if that happened here." Immediately and for the rest of the semester, the critiques were much more productive.

One student offers appreciation for an instructor who, rather than engaging students in discussions, directly told the students one at a time what he thought about each of their works while others listened:

The best studio critiques I have encountered were at the end of an intensive two week, eight hour a day, post-graduate watercolor course. We put all our works up and the instructor, though he was kind, was extremely frank about pointing out

specific weaknesses and possibilities for improvements in the work. He also pointed out the strengths that carried through each person's body of work. Mostly he talked and we listened, but it was done masterfully and each student learned from everyone else's review as well as his or her own.

Some benefits of interpretive crits

Some students thought that they especially benefitted from critiques of their works that were interpretive (What's it about?) rather than judgmental (Is it good?):

In Design II (2012) our assignment was to create a non-objective plaster sculpture that represented movement. During the critique, everyone was very involved in discussing the types of movement represented in the sculptures. Which direction was it moving and how fast? Was it melting, stretching, or twisting? The descriptions the class came up with just based solely on these fist-sized sculptures, glossy with vehicle paint, were fun and imaginative. We all talked about our processes and how we got to the final forms. The instructor had a huge part in our successful critique as he gently guided us without pushing the critique anywhere it didn't need to go.

•

One very effective professor put aside any personal opinions he had about a work to help the student meet the student's goals. He frequently asked, "What are you trying to do

here?" He tried to get the students to find their own voices, to develop a personal style.

•

When I was a grad student in sculpture (1995), I was told that something had too many loaded connotations, and some people saw something completely opposite from what I wanted to convey. The critique gave me a great deal to think about, inspiration, and it furthered my development as an artist.

•

Some of my best critiques were as a junior in college (1988). We put our work prints on the wall. The instructor opened the discussion by asking how we felt about our photographs, and we would have to talk about the feelings they provoked, and then other members of the class would join in, but the instructor never said another word. This made me feel ultimately responsible for the prints. This structure encouraged me to produce huge amounts of work.

A need for R-E-S-P-E-C-T

Based on the following narratives, students are quite able to accept negative criticism if it is delivered in ways that enables them to feel they are being respected:

My professor (1996) did traditional critiques where the work goes up on the wall and is discussed by the whole group. The

artist who is the focus of the group's attention speaks last. The instructor's manner of asking questions had all the delicate accuracy of a talented therapist. There was objectivity to her manner and a non-threatening way of pointing out strengths and weaknesses that gave each person in her class a feeling that she had a tremendous amount of respect for us all. No matter how we may have failed in certain areas or succeeded in others, we always trusted her because we knew she respected us as human beings.

•

The teacher I have (1996) knows my work well enough to know what I am trying to accomplish and he quickly points out where it's not working and what I need to do to correct it. He compares weak areas to strong areas in order to show me the difference. He gives me lists of artists' works to study. I now know how to express what I want to on the canvas and how to apply the paint and to get the effect that I'm looking for.

•

This student told of a critique that was celebratory:

I had an excellent weaving professor. She'd gather us around a loom and we would talk about what was happening. It felt like collaboration and community. We talked about design for a long, long time, formally and informally. Design had to be just right because weaving is not conducive to process-design

changes. In weaving you do not see the whole work, you see pieces as you go. When the work was completed, we all participated in the ritual of removing the weaving from the loom. It was a celebration and a time to see the completed piece.

Pleasant one-on-one crits

Critiques with a direct one-on-one approach of instructor and student have a high rate of approval. Some were private and some public with others listening on:

The best critiques I had were from a painting professor when I was an undergraduate (1995-). He met individually with each of us weekly. The student began the critique with an explanation of what he was trying to communicate and why it was worth communicating, and how he was attempting to communicate it vis-à-vis formalist principles and the history of art. The professor actually took notes that he used in subsequent critiques throughout the quarter, and we were required to keep a written journal of our critiques and responses to his queries and suggestions.

Critiques can occur by chance and happen spontaneously:

While I was working on a woodcut (1997), I was struggling with color. I hung some prints up to examine. My professor happened by and we discussed what we were seeing, what I was trying to convey, and what would happen if I cut away more here and there. We talked about different colors. I made

changes, he came and looked, and talked some more, I made more changes. It was nice to have him there making suggestions and then leaving me to think about them and to make my own choices. I ended up with a print that I am very happy with.

•

My best feedback came from studio visits with professors one-on-one. Most excellent was when I had to present my work to three members of my graduate committee at the same time. It was great because they discussed my work with each other and with me directly, so I could see the differences in their points of view. I could observe when they all seemed to agree x is a problem you should work on, or y is something that works really well. Then in discussing approaches to a problem, one prof might say, "Think about this," while another prof would disagree and say, "Here's another direction you could take this." This made me feel like I had a lot of choices and ideas to think about.

•

When I was a 2nd year grad student in painting (1996), the teacher came into my studio where I had about five paintings up. She looked at each one and let them settle in and then she picked out one she thought was successful and interesting. She used one painting to compare to the others. She did not compare me to Picasso. She offered me suggestions and helped me to see things that I didn't see. We talked about what

my goals were and she said, "Well, if you want to do that, then you need to consider working on this in your paintings." She gave me some good ideas. She showed me what I could work on to lead me to a new place. She was a guide and I could take or leave her advice. She tailored what I should work on to help me attain *my* goals. She also did not try to make me a clone of her work. She accepted my work on my terms and used her knowledge to guide me.

Beneficial peer critiques

You need not wait for an instructor to schedule a critique. You can set one up at anytime with a variety of people, including instructors:

When I was a first-year grad student, I needed feedback on my stuff because I was in a period of confusion. I made a list of my questions and passed the list out to my peers. In this way, everyone felt comfortable to reply on whatever level, and I got the most honest responses. Afterwards people approached me to discuss and analyze the work, even if I did not know them.

This is an example of a successful critique conducted by students but supervised by an instructor:

After everyone displayed their works as best they could in a studio situation (1995), the instructor assigned students to critique another student's work. Critiques were conducted over two class periods. You critiqued in one class, and were

critiqued in another. The instructor was very hard on the one critiquing. He really forced you to think, analyze, and interpret what you saw. He didn't allow any generalizations or cop-outs. He also didn't allow for cruelty or lavish praise. He had us start with strengths and weaknesses. He wanted us to really understand what was before us.

The joy of a positive atmosphere

A female professor I had was very good at facilitating discussions among her students. She played less than a prominent role than the male professors and seemed to need less control than them.

•

In an upper level ceramics critique, the prof made it a very relaxed and informal atmosphere that included a potluck meal. The informality made everyone comfortable and willing to comment on the works. She encouraged students to talk first and she asked pertinent questions. Then she critiqued. She focused on what worked in the pieces and then included suggestions for improvement and positive directions to move into.

•

As a graduate student in studio art I took Drawing classes each semester of the two-year program from 1998–2000 and I still cherish all those critiques. The instructor would always

find a positive aspect in the students' drawings to talk about, to highlight, and to feel proud of the work shown in class. When I started to take drawing classes and saw some of my classmates' drawings, I thought that some of them would receive harsh negative feedback. I could not find a good thing to say about some of those artworks myself. Later, I understood the instructor's approach to critiques, and learned from her how to create a safe environment to talk about students' art. I found the instructor's method the most generous and positive; where students would always find the best way to reflect on their ideas, and how to make their artworks look better, represent the theme most accurately, and more expressively. There was no competition in these drawing classes amongst students. No drawings were better than others. We all were there to learn from each other and enjoy the experience while practicing observation and representation. To this day, I try to find the good things in my students' artworks, even when I initially do not see much to talk about. I understand that all students deserve to express their voices and have their work valued in a nurturing atmosphere. My drawing instructor gave me this valuable lesson, more than drawing tools or techniques: a compassionate approach to conducting critiques in the classroom.

•

When I was a sophomore in drawing my professor was so very positive. Instead of telling me what was wrong with my figure drawings, he told me all the supportive things that were

right. Eventually I learned on my own what the more negative aspects were.

Conclusion

There are many different accounts of different types of critiques in this chapter: Group critiques in which students are asked to listen to the instructor, group critiques that invite or rely on discussion among students and instructors, critiques during which each student's work is discussed by the instructor while the whole class listens, one-on-one critiques that are private and others that take place in the presence of other students, peer critiques organized by the instructor, and peer critiques that a student initiates. Some critiques are planned and others are spontaneous. There are both advantages and limitations to each of these types of critiques: all of these different types can be beneficial to you.

The narratives recounted in this chapter are brief, told by only one side of the participating parties, without benefit of alternate views of what occurred and why. The narratives would likely all benefit with the inclusion of more contextual information and multiple points of view. Nevertheless, along with many positive experiences these narratives reveal troubling aspects of critiques, especially in the past, but some continue presently. The next two chapters explore how both instructors and students think critiques could be more pleasant and beneficial experiences.

2

Good crits | Bad crits

What counts as a "good critique" or a "bad critique" for students, for instructors, and for professionally mature artists? This chapter is a composite account of what instructors, students, and professionally mature artists say they want and do not want from critiques. It is an encouraging chapter, especially coming after the stories of how students have experienced difficulties in critiques as told in the prior chapter. It is encouraging because respondents generally agree with one another and provide some consensus of what works and what does not work for them during critiques. These thoughts of present day students, instructors, and artists can serve as specific and practical recommendations for critiques that work, and insights into critiques that fail.

Students are key

You are essential to a successful critique. The majority of instructors who responded to the questions "What is a good

critique?" and "What is a bad critique?" stated that students are the key factor in determining the success or failure of a critique. The following iterations place the student as the important factor in determining the success or failure of a critique. These seven comments selected from different instructors from across college campuses are typical. A critique is "good":

- When students provide a majority of the critical feedback about the work of their peers.
- When people respond and openly take part in the discussion.
- When there is a triadic dialogue among the artist, the other students, and the instructor.
- When the students are the ones inquiring about their work and seeking criticism of it.
- When the students take over discussing each other's works, raising challenging points for discussion.
- When the conversation is animated, energetic, attentive, and thoughtful.
- When there is lots of interaction.

When referring to critiques that they find unsuccessful, several instructors cited the major contributing factor as lack of student involvement. In the words of these instructors, a critique fails:

- When the room is silent except for the instructor's voice.
- When no one in the class will interact.
- When no responses are elicited.

Further, many instructors identified their biggest challenge in critiques as "not being able to get their students to talk."

When asked the same questions about what makes a "good" or "bad" critique, many students, independently of their instructors, offered answers similar to those given above by instructors:

- I do not want silence.

- It's good when everyone talks, not just the teacher.

- It works when everyone is involved.

These requests from both instructors and students for student involvement are counter to some of the expectations articulated in the prior chapter where the instructor was placed as the central key to critiques. There is a marked difference from critiques in the 1970s, 1980s, and later that point to the instructor as doing this or that. These current requests ask for more shared responsibilities for teaching and learning during critiques from both the students and the instructors.

Kinds of comments

Although instructors and students agree that lively participation by many is crucial to a successful critique, students and instructors offer cautions about what kind of participation and interaction they want in a critique. These are some typical comments made by students about the general kind of interactions they want:

- I dislike smart-alecky, rude commentary—it is hurtful and embarrassing.

- I do not want to feel like I am being attacked.
- I want someone to take my work as a serious work of art.
- I don't want dishonesty, it's important that the viewers say what they see.
- I don't want indifferent or dishonest responses.

Succinctly, aptly, and memorably, one student wrote: "Kindness makes way for openness, openness makes way for honesty and honesty makes way for growth which makes way for improvement."

Power dynamics

Instructors are often consciously aware of power dynamics in their teacher-student interactions. One instructor expressly wants "the students to take over discussing each other's works, raising challenging points for discussion." A different instructor said that a critique is unsuccessful when "students very compliantly lay aside their own inner-persons and succumb to the power and prestige of the studio teacher." One instructor explicitly stated that a critique fails when "it is instructor-centered, and only an opportunity for the instructor to impress the students with the disparity between his or her experience and ability and theirs."

Positive attitudes

These are some specific attitudinal dispositions that instructors say they want to have during critiques:

- I want a non-threatening environment.

- Overall, critiques should be positive experiences that students look forward to.

- Critiques are good when people are rational, patient, and open-minded about work.

- Critiques are good if the students express their joys and problems in making the art and apply this understanding to commenting on the work of their peers.

- I like crits to be honest yet positive, critical of weaknesses yet praising of strengths.

- It's a good critique when both the positive elements and weaknesses of a project are clearly discussed.

- I want a learning event, not an exercise in either humiliation or negativity.

Variety of voices

Students specify that critiques are "good" when there are a variety of voices heard and thoughts expressed:

- Critiques are good when voices are disparate, excited, contrary, and people listen to these different voices and ruminate on them.

- I like it when the teacher uses a little tact when discussing my work. In every piece of artwork I believe you can find one thing that works or can be discussed in a positive way and then you can talk about what is maybe not working.

- A critique is good when a lot of looking goes on before talking.

- It's good when the students are reflective, seek improvements, and discuss the work in some context beyond only the formal aspects of the art.

- A crit is good when my peers, more than the professor, give me their input, positive or negative.

- I like the sandwich method: compliment, criticize, compliment.

- I like it when the teacher suggests readings or other artists' works to look at to help improve my own work.

- It's good when new questions are raised and not necessarily answered.

- It's good when everyone learns something and everyone understands more about the project.

- It's good if no one is badly hurt or embarrassed.

- It's a good critique when overriding issues and themes, problems and solutions, shared by many of the works, emerge and are discussed and clarified.

- I want more input than "I like it," "I don't like it." I want to know what emotion the work conveys, or does their eye get stuck anywhere, and is that powerful or distracting. Stuff like that.

- I want multiple points-of-view about my work.

- I find the best critiques for jewelry designers is to have someone wear your piece for a few days and give you feedback after that.

- It's good when people see things in your work that you did not see.

- It's good when there is a search through questioning and careful probing to help you realize that you might be expressing more than the obvious.

- Critiques are good when the whole class is actively involved, all opinions are allowed, and each person has a chance to state reasons, feelings, and attitudes about form, function, and aesthetics.

Ultimate outcomes

Finally and perhaps most importantly, the following statements are from instructors and students who have articulated what they want as end results of critiques:

- It's been good if you see something about the work that you hadn't noticed before.

- The student and the instructor have gained a clear and positive view of what should be done in order for the student to produce an improved or more sophisticated art product in the future.

- The student and the teacher both learn about the student's work, the student feels heard and empowered,

the student is able to return to the work with the benefit of a different point of view, and the student begins to take the viewer into account in the conception of the work.

- The artist is enlightened about her own work, and she is open to explore the opinions of others.

- The artist knows more than when it started, the artist feels encouraged to do more work, and the air is full of ideas.

- Each student walks away from the experience positively with ideas they can apply to their own work.

- It's good when you have learned something about yourself or someone else by their interpretations.

- It's a good crit when the student gets new ideas, new energy, enthusiasm, self-confidence, and a sense of her own progress and accomplishment.

- It's good when I leave with a different perspective about my own work and others' works.

- It's good when I learn about what I am communicating to others.

- It's good if I feel OK afterwards, regardless of criticism.

There is general consensus among many students and instructors. Most want "positive" critiques, and by that they do not mean that they want to hear only good things about their work but that they want a psychological climate that is supportive and respectful. Both students and instructors would like to hear from a variety of people, not just one: They say that the insights of

their peers are very important. By the end of a critique, participants want to know and feel that they have learned something and gained something.

Artists on critiques of their own work

The following is a collection of thoughts by professionally mature artists, long away from school, about the current role of critiques in their personal professional lives. They responded to these two questions through personal written communications: "Do you now seek critiques of your own work? If so, what do you want from a crit?" The comments are offered here to motivate you to get the most you can from critiques while they are organized for you and are a regular and routine part of your class work.

A person who has only been out of school for a few years offers this first account. She is reflecting on her current art making experiences now that she is away from her college art classes:

> After I received my BFA in fine arts and moved on into the world, no longer as a student, I craved critiques. That's right, that's what I said, I CRAVED CRITIQUES. It was the strangest feeling since I didn't particularly look forward to crits while in school. What I realized is that after graduating I no longer have any feedback. No feedback at all, good or bad. There is a huge void in my artmaking process and I feel a bit lost. It might be one of the biggest lessons I learned as a post-grad. I now know critiques are valuable to an artist. I feel they

are needed to help guide an art maker to get feedback about what others see or don't see in their work. People in the "real world" do not respond to artwork and give feedback anywhere close to the feedback during critiques that you receive from fellow artists in a group critique setting.

Suzannah McEntire

McEntire's thoughts about crits may be the most relevant thoughts in this chapter for students who can still engage in informed discussions of their work.

Late in his accomplished career, photographer Jock Sturgis wrote in 2017 that:

I had a couple of friends who acted as trusted informed and intelligent commentators and sages, as it were. Their encouragement and support and cogent apprehension of my artistic project were both invaluable and crucial to me. Tragically, Walter Keller died of a heart attack several years ago and then three days later, Peter Hales was killed while riding his bike. I have felt anchorless ever since.

An artist who utilizes social media in the creation of her work stresses the importance of feedback:

For me, getting feedback is a big part of the process of making and developing the work. It's much more rewarding and comprehensive for me to have dozens of eyes on the work instead of just mine. And the work is richer, as a result. Throughout the process of making *Rethink Shinola*, 2017, a critique of the company Shinola, I sought feedback from

artists, and also from historians, activists, a union organizer, as well as from scholars of marketing, consumer culture, and Black popular culture.

Rebekah Modrak

Another professionally established artist echoes similar reflections:

After more than 30 years, I still drag my work back to my first photo teacher like a cat drags up moles and mice to the back door. I also talk about my work with my gallery owner. I respect her judgment and she makes observations about the work beyond her role as a dealer. Her role in critiquing my work makes me think of the creativity theorists who say that verification is a step in the creative process. I also enjoy showing my work-in-progress to other artists that I respect. I listen to what they have to say and watch their reactions. I think it is difficult to work without some kind of feedback, though I have done it.

Paula Eubanks

For her, response to her work is an important step in her creative process. She listens to the people who comment on her work as well as watching their reactions. She knows that it is difficult to work without some responses to what she is doing.

To satisfy some of her desire for responses to her work, another artist meets with a self-organized group of peers. In these critiques the artists first talk about their work and then listen to what other artists have to say about it:

I meet informally with a group of artists periodically. The format is usually that each artist is given about 20 minutes to talk about their work without interruption. Then the others give feedback on what was said or what was shown. I find it very helpful.

Sydney Licht

This artist, too, wants to hear from other painters: "I value responses from my peers, usually when my work has changed. Are the attributes that I am conscious of visible to other painters?" (Steven Pentak).

Some artists, however, want a broader spectrum of viewer responses than what they receive from professionals. A photographer who often makes photographs of children learns by showing her work to children:

When I have the opportunity, I love to show my photographs of kids to kids. When I give slide shows of my work in schools, the children respond automatically. Some photos get big squeals, others not so much. The kids' responses are the most honest because they are the most interested in seeing new things.

Patty Mitchell

Another artist also says that she enjoys hearing how people who are not artists and who do not necessarily know a lot about art react to the things she makes. She is interested in hearing whether her works mean something to others who happen to see it:

I do show my work to others, mostly when people come to my house where much of it hangs. I also give pieces away as gifts to unsuspecting friends and relatives. I care a lot about content, and the content is ambiguous, probably more so than I want it to be. So, I especially like to hear people respond to it in a way that lets me know I have communicated something of what I intended to. Just today, I picked up a piece at the framer's and brought it into my office so as not to leave it in the car. My assistant walked in, saw it, and said, "Oh, it's got such a dreamy quality. I can almost hear that music." These are the kind of comments I like to hear.

<div align="right">Betsy DiJulio</div>

DiJulio's comments are reminiscent of the practice of Josef Koudelka, the Czech-French photographer, who brought a box of photographs to New York City and stopped and asked strangers on the street if they would be willing to look at them. While they looked he quietly observed their reactions.

Unlike art students who follow course calendars or the pacing of their instructors who set dates and times for critiques, some artists choose when to show their work to others for comments:

I only seek out critiques on a small number of occasions, usually when I am moving to a new direction, for instance, when I was moving from photographic installations to performance art. I was hoping that the input would help dissipate the anxiety and insecurity I was feeling. I wanted to hear what other people thought to help me figure out what I thought. I sought input from former professors, and they

were helpful. I also rely on two artist friends that I have had long conversations with. I have even met one friend in New York and Chicago just to spend weekends talking about our work. We talk about philosophical issues, revolving around what we want to get emotionally and spiritually out of the work that we do.

<div align="right">Jeffery Byrd</div>

A painter asks for critiques at important phases of his career, saying:

I sometimes seek critiques if I am at a career juncture. I want to know if the concept is sound. Did I make my point? Is the work qualitative regarding craftsmanship, composition, and humor? It is very important to me that humor eases the viewer into understanding that there is a very serious side to my work.

<div align="right">Alfred J. Quiroz</div>

Note that when Quiroz asks for a critique, he wants responses to his technique and compositions and especially to the social content of his work and how viewers receive it.

Another artist also seeks a diverse range of voices but waits until the time is right before soliciting comments:

I solicit responses from as diverse of an audience as possible but only upon the completion of a work or series of works. I find that honest responses concerning any and all aspects are helpful regardless of the viewer's age or experience.

<div align="right">Pheoris West</div>

Some artists are cautious about soliciting responses. This artist explicitly protects her work from viewers until she is ready for it to be seen:

> I like feedback but I try to discern what is helpful from what is harmful. After twenty-five years, I have developed an intuitive understanding of what I want to say and how I want to say it. I am very careful about showing my work or even allowing anyone in my studio before the time is right.

> Dee van Dyke

She acknowledges that she experiences some feedback as harmful rather than helpful.

This painter wants to keep critics out of her awareness while she is working, but then accepts criticism after she has finished a piece, but with caution:

> It's taken me years to get away from some of the negative voices in my head (mostly friends!). I want to escape those voices when I'm *working*. However, when I am evaluating what I've done they can assist me in being honest with myself. I have plenty of vulnerability as a painter. I have a friend who looks at my work and knows exactly what's wrong with it and what he thinks I *should* do. I have a little mantra: "This is his opinion." I still prefer criticism to silence.

> Margo Tassi

Another artist has specific wants when seeking commentary about his work: One type of response he wants is supportive

commentary, and another type is commentary that explores the social issues that he wants to be essential in his work:

> I become agitated when someone responds only to beauty and sees no other reason or incentive to explore issues that I felt I had elicited visually. I guess the worst response is no response, though ... I think artists seek support for their work, not criticism. We seek validation, if only from a few other artists. What I am becoming increasingly receptive to is critical commentary about content and social relevance. This strikes the sensitive nerve and makes me question my motives and re-examine my methods, language, and the audience to whom I should really be speaking. Such critics hold philosophical views radically different from those that only address formal and expressive concerns. We need aesthetic criticism, but not the internalized kind that exists outside of the issues of the human condition. We don't need autonomy. That didn't work. We need responsibility and collective activism.
>
> Hank Margeson

Margeson seems to be reacting against viewers who only want to notice the formal beauty of his work while avoiding the social content in his work.

This artist says she comes to know her work better when she hears herself talk about the work:

> When I show and discuss my work with someone who I respect as an artist, critic, gallery owner, I find myself asking

questions but in the very act of asking, I know the answer! While I might be unsure about something, once I talk about it, I know what to do. So perhaps verbalizing my thoughts helps me make a decision and not the person I'm talking to. So maybe I should talk to my cat since she frequently watches me paint!

<div align="right">Sandra Hildreth</div>

Another artist wants more feedback on his work but has a difficult time finding enough people who are interested in his chosen medium of tapestry:

Since my work is tapestry, critiques are problematic for me. Tapestry artists continue to find museum curators and art critics either hostile to or ignorant of contemporary tapestry work, and critical reviews are very rare. When I have access to some other tapestry artists whom I admire, their feedback is very valuable to me.

<div align="right">Tommye McClure Scanlin</div>

This artist is aware that whether or not you want verbal responses to your work, you will hear it if you make your work visible:

Art is there. People cannot avoid it. When our house cleaner sees a new work, I know that if she does not say anything the first time that she sees it that she does not like it. I am always curious about people's reactions–my wife's, friends who come to our house, gallery people, critics. Each person has their

own thoughts when confronted by my work. I accept that and like it.

Ben Schasfoort

Kiki Smith reflects on her long career as an artist and says:

Certainly, when I was in my twenties in New York, I spent most of my time visiting friends and having them visit me and talking about our work, and this was immensely helpful, and felt invigorating and safe to be doing with other artists of my own age. As I get older, it may be less so, because by this time I know I am just stuck being myself, that even when my work comes up short for other people, there is nothing much I can do about it, because I am just given what I am given. But, I certainly never mind suggestions from friends of how to make something better. If their suggestions are useful, there is certainly nothing better than being open to and benefiting from other people's creativity.

Kiki Smith

Sean Scully asserts simply and boldly: "Criticism is crucial. Art is a collaborative exercise. Without criticism you can never progress."

Perhaps a fitting ending to these accounts from a range of artists who have been making art for many years is a thought expressed by Stanley Hayter, the renowned printmaker who founded the Paris Atelier 17 studio, where he collaborated with and influenced such artists as Picasso, Giacometti, Miró, Calder, Chagall, Pollock, and Rothko: "The only kind of criticism that

matters is the criticism you ask for." Hayter told this to Tom Lang in Paris, 1977, implying that you get to make choices about what you will let matter to you about your work.

Conclusion

There is encouraging consensus in this chapter among the key parties involved in studio critiques: students, instructors, and professional artists. We generally know what we want and do not want from critiques. There are diverse ways of getting to what we want, and these are explored in the following chapters.

3

Skills and attitudes

Successful critiques are dependent on effective communication. This chapter offers considerations for improving communication in groups, which are the usual format for studio critiques. The first part suggests strategies for effective group interactions offered by specialists in communication studies. The second part puts these general considerations and recommendations into the context of studio critiques. Group discussions are common in schools, and more importantly in a larger view of education, effective communication is a well-established criterion of healthily functioning democratic societies. Thus, critiques about art can be occasions to hone skills of communication that can benefit you and the world inside and outside of the art studio.

Lessons from a psychologist

Irvin Yalom of Stanford University is the author of a text for psychology students studying group interactions. Through his

years of clinical practice with clients in group therapy, Yalom offers some valuable insights for living life wide awake that can pertain to critiques.

As a therapist, Yalom believes that his primary work is to offer his full presence to those he works with. He trusts that people will find what they need without a specified action, interpretation, suggestion, or reassurance from him. Thus, he reminds himself "the most valuable thing I have to offer is my sheer presence. . . . Stop trying to think of something wise and clever to say. Let go of the search for some dynamite interpretation that will make all the difference."[1]

He grounds his practice in a basic assumption that you are in search of purpose and meaning in your life, and thus offers the following "ways of being":

- Recognize that life is at times unfair and unjust.

- Recognize that ultimately there is no escape from some of life's pain.

- Learn that you must take ultimate responsibility for the way you live your life no matter how much or how little guidance and support you get from others.

- Recognize that no matter how close you get to other people, you must still face life alone.

- Face the basic issues of your life and death, and thus live your life more honestly and be less caught up in trivialities.

[1] Yalom, I. D. (2015), *Creatures of a Day: And Other Tales of Psychotherapy*. New York: Basic Books.

- The center of your self-esteem should be within *yourself* rather than in the mind of another.[2]

Yalom's thoughts are concerned with issues beyond those about art, but his ideas are offered here as encouragement to invest more deeply in many aspects of life including critiques.

Recommended techniques for effective communication

Professionals of communication studies offer specific techniques for engaging in effective group discussions no matter the topic. To be able to beneficially engage with others during group discussions, techniques that they recommend can be very helpful.

The Work Group for Community Health and Development at the University of Kansas offers the following hallmarks of effective group discussions.[3] These hallmarks may need some modification depending on any particular critique. They are quoted here verbatim as self-evident without need of further commentary:

- All members of the group have a chance to speak, expressing their own ideas and feelings freely, and to pursue and finish out their thoughts.

[2] Yalom, I. D. (2005), *The Theory and Practice of Group Psychotherapy.* 5th edition, New York: Basic Books, 88.
[3] Work Group for Community Health and Development, http://communityhealth. ku.edu (accessed 17 June 2017).

- All members of the group can hear others' ideas and feelings stated openly.

- Group members can safely test out ideas that are not yet fully formed.

- Group members can receive and respond to respectful but honest and constructive feedback.

- Feedback could be positive, negative, or merely clarifying or correcting factual questions or errors, but is in all cases delivered respectfully.

- A variety of points of view are put forward and discussed.

- The discussion is not dominated by any one person.

- Arguments, while they may be spirited, are based on the content of ideas and opinions, not on personalities.

- Even in disagreement, there's an understanding that the group is working together to resolve a dispute, solve a problem, create a plan, make a decision, find principles all can agree on, or come to a conclusion from which it can move on to further discussion.[4]

The Work Group recommends ground rules for discussions, quoted here verbatim:

- Everyone should treat everyone else with respect: no name-calling, no emotional outbursts, no accusations.

[4] Community Tool Box, "Techniques for Leading Group Discussions," University of Kansas, http://ctb.ku.edu/en/table-of-contents/leadership/group-facilitation/group-discussions/main (accessed 24 May 2017).

- No arguments directed at people – only at ideas and opinions. Disagreement should be respectful – no ridicule.

- Don't interrupt. Listen to the whole of others' thoughts – actually listen, rather than just running over your own response in your head.

- Respect the group's time. Try to keep your comments reasonably short and to the point, so that others have a chance to respond.

- Consider all comments seriously and try to evaluate them fairly. Others' ideas and comments may change your mind, or vice versa: it's important to be open to that.

- Don't be defensive if someone disagrees with you. Evaluate both positions, and only continue to argue for yours if you continue to believe it's right.

- Everyone is responsible for following and upholding the ground rules.[5]

The Work Group identifies some "do's and don'ts" for those engaged in group discussions, paraphrased here:

- Model the behavior and attitudes you'd like others to use.

- Use body language, tone of voice, and words that

[5] Community Tool Box.

encourage participation.

- Be welcoming toward someone newly joining a discussion.

- Be thoughtful, courteous, and aware of people's reactions to what is being said.

- Control your own biases and refrain from imposing your views on others.

- Don't assume that anyone holds particular opinions or positions because of their culture, background, race, or style.

- Don't assume that someone from a particular culture, race, or background speaks for everyone else in that group.

- Don't be the font of all wisdom.

- Disagreements can be helpful: explore them rather than soothe them over.

- Don't dominate the discussion.[6]

Rules of engagement

Lastly, these are some rules of engagement for group discussions adapted from the United States Air Force Academy that are direct, succinct, and memorable. They are harmonious with what

[6] Community Tool Box.

has already been articulated above, and can serve as further motivation for effective critiques:

- Take free-fall risks. Express your views without prejudging them. What you have to say may have that golden perspective that helps us to break through confusion and ignorance.

- Listen carefully. Focus on people's thoughts, not on their efforts to express them.

- Promote democracy. Encourage a wide variety of viewpoints and opinions.

- Extend charity. Always give your colleagues the benefit of the doubt.

- Practice civility. Never forget that colleagues have fundamental, inviolable worth as human beings and always must be respected as such.

- Encourage others to take part and applaud the efforts of those who do.

- Embrace ambiguity. There is very little closure in life. Most of the solutions we discover are at best tentative and hypothetical.

- Build community. Constantly seek new ways to perpetuate and expand the learning community.[7]

[7] No source available: retrieved from a handout from Professor Bernard Sanders, Professor Emeritus, Department of Philosophy, The Ohio State University, in the 1980s.

General considerations for group critiques

The following suggestions are based on experiences while participating in critiques. They are suggestions that require decisions about if and when to apply them, and by whom.

Attitudes

The attitude you bring to any critique will greatly color the critique itself and its outcomes.

- Come in with the attitude that you will take away something useful from the crit.

- Have an attitude of cooperation rather than competition with your fellow students.

- Leave with the belief that you can put something from the crit into practice for your own work or life.

Space

The actual physical space in which a critique is held will likely be consequential in how the crit goes.

- It is essential that all who are participating can clearly see the work being discussed.

- Arrange the group so that people can see one another as well as the work being discussed. A semi-circular formation may be best.

- Be sure that everyone can hear one another throughout the critique.

- Disallow participants from physically situating themselves behind or outside of other viewers.

- Allow for physical comfort during critiques.

Time

The time allotted for critiques in different situations varies greatly. Some critiques in advanced courses are marathon sessions at the end of a term that may last several hours a day and into the evening while most will be more frequent and of shorter duration.

- It will be helpful for you to know ahead of time how long a critique is expected to last so that you can pace yourself accordingly.

- Knowing the end time allows you an opportunity for seeking some closure before the group disassembles.

- Knowing the total amount of time gives you occasion to allot a fair amount of time for consideration of each person's work.

- For equity, have a time keeper track minutes so that they are distributed equally.

- Decide ahead of time whether some or every participant's work will be attended to during this critique.

- Through the duration of a course term, try to disseminate time fairly to all members in the group.

- If time and numbers do not allow for everyone's work to be discussed, consider asking for volunteers who either want or do not want their work considered during this particular critique.

Frequency

Critiques can and likely will be spontaneous at times during a school term. One-on-one critiques can happen during a class or outside of one. Group critiques are usually planned and announced ahead of time. Some classes have crits, long or short, throughout the term and other classes might only have one at the end of a term. Critiques can be of finished work or works in progress, in a gallery space or in the working studio.

- If you want more frequent response to your work, you can always seek them from your peers or your instructors.

Critique formats

There are many different formats for critiques that are available and each has its advantages and limitations: critiques in which the instructor directly imparts information with little input from the students; critiques with the whole group that are led by the instructor; critiques by the instructor that are focused on students individually, one at a time, while the rest of the class listens; critiques that the instructor facilitates asking for lots of interaction with the students; critiques that are led by students; critiques during which the whole class is divided into smaller

groups; critiques that involve written responses; and other formats not invented yet.

- If one format becomes too predictable and nonproductive, consider trying different formats.

- Different formats accommodate different learning styles. Shy students can learn better in small groups. Some students may be more forthcoming and insightful through quietly writing their comments while others prefer speaking spontaneously. A variety of formats allows for diverse thinking and styles of interacting.

Interactions during critiques

How you and your fellow discussants interact with one another during critiques will seriously affect your experiences in positive or negative ways.

- Your comments are valuable. Speak clearly, slowly, and loudly so that everyone may hear and understand what you are saying.

- Your comments are valuable to the whole group. Side conversations with a person next to you will take you away from the whole group and prevent the larger group from considering what you have to say.

- Side conversations during a group discussion may seriously impair the larger discussion.

- Listen by concentrating on what someone is saying rather than formulating what you want to say.

- Be comfortable with silence: Good questions require time for thinking before answering.

- Exhibit positive body language: make eye contact, sit forward, and indicate that you are listening.

The artist's role

There are many options during critiques for the role of the artist whose work is being discussed and each has important implications for learning.

- Consider having the artist whose work is being discussed assume the posture of "a fly on the wall," quietly observing the group and each speaker, listening carefully but not speaking. The artist then does not need to orally comment on or defend their work and might become more receptive to what is being said about it. The artist can learn how their artifact is being understood without their telling the audience what they intended or meant to express. The artist can then decide whether the object itself has conveyed their intent without their explanation of it.

- Consider leaving the artist whose work is being critiqued out of the discussion altogether in order to encourage the viewers to be active interpreters rather than relying on the artist to determine meaning for them.

- You can learn a lot by attentively listening to comments that are not specifically addressed to you. Instructors

often expect you to take in what they are saying to others, especially during a group crit.

Artists as spokespersons for their art

Many instructors, schools, and gallerists expect you to be able to talk intelligently and informatively about the work that you make.

- If the purpose of a particular critique is for the artist to become more articulate about what they have made, then hearing them speak and then evaluating their words as well as their work may be helpful for the artist.

- Critiques can be concentrated on words as well as works: Do the words make sense? Do the words match the work?

Let the artist formulate the questions

It may sometimes be helpful to let the artist whose work is being considered pose the questions being asked about their own art.

For example, when he was a graduate student, Nate Larson posed these questions for a critique of his series *Tortilla Manifestations,* photographic depictions of sightings of Jesus in ordinary objects:

Are we supposed to believe these photographs? Should we want to? How should we feel about them if we do believe them? Should we do anything about those feelings? If we don't believe them, what then?

What kinds of connections do these four series of images have? Do they have the same intentions?

Would the same people or person take or seek out these types of photographs?

How do you ultimately interpret these photographs in this art gallery context? How or would that interpretation change if the context were changed? Say, the Internet, a library book, on the local drug store bulletin board.

He wrote these questions before the critique and then let the instructor conduct the discussion while Nate listened.

To give or not to give advice

Whether to give advice to artists any time and especially during group critiques is a decision that is often overlooked or unintentionally neglected. It may be more productive for the development of artists to hear problems or issues about their work than hearing others' solutions for it.

- In a group critique, consider being a carefully listening observer rather than an instant problem solver.

- Resist offering solutions to the artist's problems and let the artist eventually solve them their own way.

- Refrain from trying to persuade the artist to make the work that you would make. Let them discover their own expressive interests.

- Consider only giving advice to artists if asked, in one-on-one situations rather than during group critiques.

Conclusion

Many of the directives and suggestions offered in this chapter closely match requests made by students and instructors in Chapter 2. The suggestions also compliment what professionally mature artists have said about their wishes for critiques in their current lives. If you follow the suggestions offered here you can help to prevent some of the difficult experiences by students in their narratives about critiques in Chapter 2. Having now addressed some of the means of how to better engage in critiques, the chapters that immediately follow delve into the content of all that can be considered during critiques.

Recommended activities for initiating critiques

The following activities are recommended by various instructors as effective ways to introduce critiques that might be especially useful early in a course or for those new to critiques.

•

Speed dating. This moves quickly. Have a stopwatch ready.

Students form two rows (A & B) that face each other and introduce themselves. Each student from Row A gives their piece to the person across from them in Row B. For 1 minute, students in Row B give positive feedback on Row A's pieces. Then for 1 minute, students in Row B indicate areas of possible improvement for the piece opposite them in Row A.

Switch pieces (Row A is now looking at Row B's pieces).

For 1 minute, students in Row A give positive feedback to the person across from them in Row B.

For 1 minute, students in Row A indicate areas of possible improvement on the piece opposite them in Row B.

Everyone moves one spot to their left. (Remind them to introduce themselves each time they switch.) Repeat the process. The critique ends when the pair of students who originally faced one another line-up again. The whole critique will last from 30 minutes to around an hour depending on the number of students in the class. (James Thurman, University of North Texas)

•

I like to use this question: "Which piece demands a comment from you?" (Anonymous)

•

I have students in groups of two or three walk around to see the works of others and give the artists a chance to discuss what they were trying to accomplish. This softens things up a bit when we have a full class critique. When I make comments, I offer extra support to some who might be feeling less good about the experience, and some good words to those already far ahead to keep them plugging away. One does have to learn how to say what one wants to say but couch it so that it is supportive yet

allows for the chance to learn and improve. (Pearl Greenberg, Professor Emerita, Kean College of New Jersey)

•

I like to display the work to be critiqued in a different environment such as a gallery space with white walls and track lights. This helps to give the work a sense of professionalism to which students seem to respond in a positive manner. (Craig Krug, Pittsburgh State University)

4

Description

Describing what you see or hear or otherwise sense in a work of art or design should be the basis for all other comments on that work. To describe a thing is to name it and its characteristics and qualities. Describing is a process of overall observing, particularly noticing, and telling what you sense. It can be a relatively simple and straightforward process that does not entail much risk on the part of the viewer; nevertheless, it is difficult to get people to describe what they see during crits. People seem to believe that if what they are asked to describe is in front of you and them, then they think there is no need to say what they see because they wrongly assume we all see the same things in the same way. We do not. We look at things differently, we notice different aspects, and we use different words when we tell about what we notice. Descriptions enhance what we see. Descriptions can also limit what we see if the descriptions are too limited or overly definitive. To be able to describe well is a skill to be acquired.

Everything is important in a work of art; everything counts, whether or not the artist wants it to count. If it is there in the

artwork, viewers will notice it and try to make sense of it. When you tell others what you see, they can then see it perhaps for the first time, see it differently because of what you say and how you say it, or notice its significance in a new way. If you do not describe it, they may never see what you see or otherwise overlook its presence and its importance. If they do not see it but go on to interpret or judge the work, their interpretation or judgment will not account for the whole work and it may then be a flawed interpretation or judgment for failing to account for what is there.

Marie Howe, who teaches writing to college students, explains her difficulties in getting students to describe. She says to them, "Just tell me what you saw this morning in two lines, like I saw a water glass on a brown tablecloth, and the light came through it in three places." They try to say, "It was like this; it was like that," but in this descriptive activity, she does not allow comparisons or metaphors. If someone says, "Oh, I saw a lot of people who really want," she responds with, "No, no, no. No abstractions, no interpretations." She says resisting metaphors is very difficult because you have to actually endure the thing itself. She wants them to "be with a glass of water," but they say, "Well, there's nothing important enough." Howe says, "That's the whole thing. It's the point." When they learn to delight in the actual, it is thrilling: "The slice of apple, and then that gleam of the knife, and the maple tree outside, and the blue jay."[1] Howe's observations about writing descriptions apply to describing works of art.

[1] Tippett, K. (2017), *On Being*, Marie Howe, "The Power of Words to Save Us," https://onbeing.org/programs/marie-howe-the-power-of-words-to-save-us-may2017/ (accessed 24 August 2017).

Descriptions, interpretations, and judgments overlap

The activities of describing, interpreting, and judging are different from one another but they overlap. To describe is to identify with words what you see in a work, to interpret is to infer meaning about what you see, and to judge is to assign value to what you see. These distinctions seem simple but they are not because how we understand something will affect how we describe it, and how we value something often colors how we describe it.

The seemingly simple statement "I see a cat" is complex and already interpretive. The phrase requires knowledge of cats, English usage, awareness of seeing, and of the interaction of seeing and saying and knowing. To say, "I see a painting of a cat," adds the complexity of knowing differences between a thing, a representation of a thing, and knowledge of the medium of painting. For the phrase to be true it is dependent on your knowledge of cats as distinct from other furry animals of similar size, and to know the difference between a painting, a pencil drawing, and a photograph.

The phrase "I see a painting of an angry cat" is yet more interpretive although it seems to be simply descriptive. To identify the cat as "angry" you have inferred anger from the cat's hissing, arched back, flickering tail, and raised fur, or perhaps the sound of hissing is enough for you to be warned. Also, to describe "a cat" requires a different cognitive procedure than describing "the cat." To say I see a "beautiful" painting of a cat or "a painting of a beautiful cat" entails value judgments and

adds further complexity to what might seem like a descriptive statement.

Culture affects perception and description. If you grew up with cats as favorite family pets or were raised to be scared of animals or if you have been clawed by a cat, you may perceive and describe all cats as friendly, worrisome, or angry. If you were raised in a culture that considered cats as a good source of protein for the human diet or conceived of cats as sacred beings, your responses to pictures of cats will be affected. The point here is to be aware of what you may be bringing to a critique when you think you are simply, neutrally, and objectively describing what you see. In group critiques with members from different backgrounds, varied descriptions can beneficially enhance, broaden, and deepen the discussion and considerations of the object being discussed. Hearing how others describe what you see can enlighten you about depiction and perception.

When you interpret what you see without describing it, your interpretations may confuse and confound. How did you come to your decision of meaning? Interpretations without the benefit of descriptions are overly simple and often leave too much out. Interpretations and judgments without descriptions lack a factual basis and are thus suspect; interpretations and judgment that are grounded in descriptions carry credibility.

Judgments can and do influence how we describe works. If you do not value a work, think that it is less than successful or a downright failure, your judgments will likely seep into your attempts to be descriptively neutral. While understanding that

descriptive neutrality is hardly possible, you can at least be aware of whether and how your judgments may be coloring how you are describing something. If your task is to describe, try to modify what you are about to say before you say it so that it is more neutrally descriptive and less judgmental.

We will further explore the topics of interpretation and judgment in the following chapters. For now, we are considering description as a rather straightforward data gathering process and data reporting opportunity. We want to gather adequate observations about a work in order to later speculate about the work's meaning or offer our thoughts about its value. As a starting point, everything in a work can be noted as potentially very important to the work's meaning and success. Ultimately, what to include in a description is dependent on what you think the object expresses, and how well it expresses it.

Describing subject matter

Descriptions can and should identify any subject matter that may be in the work. "Subject matter" consists of people, places, and things depicted in a work of art or design. When a work refers to something in the world, the Second World War, for example, then you can give an account of the historical event because it is likely relevant to understanding the piece. When looking at nonrepresentational work, consider its elements to be its subject matter: colors, texture, numbers, words, trademarks, brand names, and other aspects that are present.

Describing medium

The term "medium" (singular) refers to the material used in an artwork and how it is used. "Medium" is also used to refer to "artform," that is, general types of expression such as poetry, ballet, painting, product design, filmmaking, conceptual art, space enclosure, ceramics, and so forth. Descriptions should account for the media (plural) used in the work and how those media are used: "The paint is applied thickly," "the wood is rough hewn," "the steel is polished," and so forth. Vincent van Gogh and Jackson Pollock both made paintings, but they applied it differently: When describing their work you can articulate such differences most easily by comparing and contrasting their paintings.

Describing form

Descriptions should account for the formal aspects of the work. Formal aspects of a work include some or more of these elements of art: point, line, shape, mass and volume, texture, value, color, space, time, motion, words, and sounds, each of which is briefly defined here. Elements of art are often presented along with principles of design, that is, ways in which the elements can be arranged. Principles of design are interpretive and judgmental considerations of the ways elements are put together to form effective and meaningful compositions. Principles of art are discussed in the following chapters on interpretation and judgment.

The following definitions of elements of art are rudimentary and you likely know them already. If so, let the definitions be reminders of all that can be described in a work.

A "point" is a dot or small circular point.

A "line" is a series of connected points. Lines can be actual or implied. An "actual line" is a series of points made by a tool moving across a surface. An "implied line" is a series of points that the eye recognizes as a line. "Perceived lines" occur where areas of contrasting color or texture meet. "Contour lines" are outlines of objects or shapes. A "gestural line" conveys the energy of the artist's hand as it moves across a surface. Lines can be thick or thin, long or short, smooth or jagged.

A "shape" is a two-dimensional area with defined or implied boundaries that can be measured by height and width. A "geometric shape" might be a rectangle, triangle, circle, or polygon, often human made. An "organic shape" is one that resembles irregular shapes often found in nature. An "amorphous shape" lacks clear edges and is ambiguous and indistinct. A "positive shape" is a dominant shape on a ground. A "negative shape" is one that is left over or around a dominant shape. A "figure" is a shape on a background. A "ground" is a background on which marks, shapes, or figures are placed.

"Mass" refers to actual or illusory three-dimensional bulk. "Volume" refers to the measurable area that an object occupies—its height, width, and depth.

"Texture" is the actual or implied tactile quality of a surface. "Actual texture" is the tactility of a surface. "Implied texture" refers to the illusion of tactility, and "invented texture" gives the impression of tactility.

"Value" is the relative degree of light or dark. Value without color, ranging from white to black, with variations of gray in between is called "achromatic value."

"Color" is the effect on our eye of different wavelengths or frequencies. "Hue" refers to a name of a color family or an area on the color spectrum. "Primary" colors are the basic colors that cannot be broken down into other colors and that can be combined to make other colors. "Intensity" is the strength or weakness of a color and the "value" of a color is the lightness or darkness of a color. In the "subtractive" color process the mixing of pigments result in all colors being absorbed or subtracted except the desired color. In the "additive" color process by which the mixing of colored lights combine or add to make other colors. A "tint" is a color that has white added to it, a "shade" is a color that has black added to it, and a "tone" is a color that has gray added to it. "Opaque" colors disallow other colors from shining through them and "transparent" and "translucent" colors transmit or diffuse light. "Local" color refers to the color that an object reflects in the real world and "arbitrary" colors are those chosen for expressive rather than representative qualities.

"Space" is an expanse of three-dimensionality in which object and events appear. "Three-dimensionality" includes height, width, and depth. Space can be actual or illusional or virtual: "actual" space is an expanse in three-dimensionality, "illusional" space is an appearance of an expanse on a two-dimensional surface, and "virtual" space refers to computer-based environments that seem real. "Positive" space is an area filled with elements of design and "negative" space is an empty area. In two-dimensional work, space can be considered as occupying a "foreground," "middle ground," and "background." In two-dimensional work, space can be rendered as if it were three-dimensional by use of technique that renders objects in perspective.

"Time" is defined as the continuum of experience in which events actually or apparently take place. "Actual" time is the duration of an event that can be measured by a clock; "implied" time is an illusion of time and its passing. Time has actual or apparent qualities of duration, tempo, scope, and sequence.

"Motion" is the actual or implied changing of position. "Implied" motion is the illusion of movement and the passage of time or distance. "Recorded" motion is the capture of movement with lens-based media.

Words are important elements of art, especially in graphic design. Words are both denotational and connotational: the word "red" denotes a color, but it may carry many different connotations such as anger or danger or passion. "Text" and

"copy" are interchangeable terms in graphic design that refer to a body of words, as distinguished from images, in an artifact such as a poster or book. Spoken words are important elements in many forms of media arts including film and television.

Sound is an element of art often used in media arts. "Recorded" sound is that which is saved for replay as part of an artifact. In silent media, sounds can be implied.

Describing contexts

The contexts of the work are too often overlooked or merely assumed when viewers offer descriptions of a work, especially during critiques. There is always a context in which the work is perceived. The viewing context includes aspects of where you are seeing the work, and where and to whom its maker intends it to be eventually seen. You are most likely critiquing a work within a school context, such as a computer lab or a sculpture studio. Such a context already carries with it assumptions: perhaps the place it is shown indicates that the object is supposed to be either "art" or a "product," and assumptions are likely to follow and they should be noted. Viewing context also includes where a work would ideally be shown: in a hardware store, on a billboard along a country road, or in a New York City art gallery.

The context of the maker includes who is making the work, where they are in their artistic development (beginning student, grad student, young professional, mature artist), whether the

work is in-process or complete, and whether it is made in response to a specified class assignment.

The work's social context includes its time and place in the world: Is it part of a political campaign, does it attempt to further a social cause, who is its intended audience and the audience's social makeup, how is the work meant to function? The work also has an art historical context: Try to identify its conscious or subconscious artistic influences.

Description and formal analysis

A formal analysis is a discussion during which viewers examine the elements used in a work of art (point, line, shape, etc.) and by what organizing principle the elements are arranged (symmetrical balance, for example). In a description of an object, it may be necessary to name the shapes it employs and their textures and colors, but such identifications of elements are not sufficient in themselves to count as a formal analysis. You must further explain how the elements interact with one another by how they are put together on a picture plane or in a space: "The blue looks heavy" may be descriptively apt but it does not go far enough. You need to also interpret the effect of the heavy blue on the possible meanings of the piece, and then to judge whether the heavy blue is contributing to or distracting from the overall idea and expression of the piece. Formal analyses require description, the topic of this chapter, but also require interpretation and judgment, which will be explored in the following chapters.

A description of the form of a work, even a thorough description, should not be considered a thorough critique. However, sometimes in critiques observations of the form of a work are assumed to be sufficient for a critique: that is, viewers who make comments on a work's form and how the work has been structured, often mistakenly think that they have indeed critiqued the work. A significant problem with formal critiques is that they stop short of a fuller examination of a work. They too often do not account for the feeling of the work, or the work's possible meanings that are affected by how the elements are put together. Too often critiques based only on form do not go further and interpret the cognitive and emotional implications of the works being discussed, or judge their effectiveness. Yes, the work may utilize many different blue lines of varying sizes but how do these lines influence the work's expression or utility? What is the work about? What's the work for? How does a consideration of the form of the work affect your response to it? Questions like these can only be answered with interpretive and evaluative thinking and talking.

Some conclusions

It is not necessary to begin every discussion of a work of art by first describing it. Critiques can open with a judgment: "I think this is the best piece on the wall." Critiques can also start with interpretation: "What seems to you to be the most politically relevant piece on display?" However, to adequately defend a

value judgment or explain an interpretative statement, you will need to describe what you are referring to in the piece you are discussing. This book does not insist on any particular order of procedures.[2] Discussions of works of art can begin in all kinds of ways but to be convincing, they ought to be grounded in what can actually be seen and experienced in a work of art.

Description itself should be a very important part of a critique but descriptions of works are too often neglected altogether or glossed over too quickly. Accurate and thorough descriptions can be valuably informative both to the maker of the work and those viewing it. Sometimes, just describing a work may be enough for a critique, especially in first critiques, or beginning sessions in a new course. Describing is a relatively low risk activity for everyone participating in the critique that allows everyone to quickly have a voice just by saying out loud what one notices in a work. When you are at a loss of what to say, consider simply naming what you see.

When you make the effort to describe a work, it is likely that you will notice more than if you skip description and jump right into judgment or interpretation. If your work is being described and you carefully listen, you will have a very good opportunity to hear what viewers attend to and what they may miss. If they overlook or do not pay enough attention to an aspect of your

[2] Edmund Feldman, however, who has considerably contributed to the topic of critiques, maintained that discussions of works of art should invariably follow this order: first describe and only describe, then provide a formal analysis, then interpret, and then and only then, make a judgment. Feldman, E. B. (1993), *Practical Art Criticism*, Englewood Cliffs, N. J.: Prentice Hall.

work, you may well consider why this might be happening and if you want to make adjustments accordingly. Ultimately, critiques that do not pay enough attention to what can actually be seen or otherwise experienced in a work can easily result in comments off the mark. Description is crucial.

Principles of description for critiques

- Description is a data-gathering process.
- Description can be a data-reporting process.
- To describe something is to offer important information about it.
- Descriptions should be factual based on what you can see or sense in the work.
- When gathering descriptive data, everything matters.
- Facts about the artist, title, medium, size, date, and place or type of presentation are important descriptive data.
- Formal analysis is a combination of description and interpretation and judgment.
- Description, interpretation, and evaluation are interdependent activities.
- Interpretations and descriptions are meaningfully circular: Description is dependent on interpretation and interpretation is dependent on description.

- Descriptions should offer information drawn from within and relevant information that the work refers to.

- Descriptions can be infinite: Relevancy toward interpretation or judgment is the determining factor of what to mention to justify an interpretation or judgment.

Descriptive critiques to try

I. "I see . . ."

This is a good beginning exercise for a critique. It gets everyone to say something, encourages people to listen to one another because repetition is not allowed, is enjoyable in a game-like way, reveals a lot about what is being described, and builds communal cooperation.

1 Choose an object that is large enough for everyone to see. Gather viewers in a circle around the object or in a semicircle in front of the object.

2 Take turns naming one thing (and only one thing) that can be seen. First person, "I see red"; second person, "I see cross-hatched lines"; third person, "I see a puffy white cloud"; fourth person, "I see . . ." Make sure everyone can hear what is said and can see what is identified. If some cannot see what has been named, they can ask for clarification. Move along quickly. Do not repeat what has already been noticed unless with different words.

3 Go around the circle again to note more aspects.

4 Once identifying new aspects becomes difficult, stop taking turns but ask if anyone has something that has not yet been mentioned.

5 Ask what insights have been gained from this exercise.

Space for notes:

II. "Seeing | Listening"

This is an engaging and enlightening exercise for learning how to describe a work of art accurately and completely. It has participants play two different roles, that of speaking descriptively and that of listening carefully.

1 Divide the whole group into two halves. One half is the "seeing" group and the other group is the "listening" group. Have each group face away from the other group so that the groups cannot see one another.

2 While the listening group covers its eyes, place a large object in front of the seeing group so that they can observe it clearly. Only the seeing group gets to see the object. The listening group allows no peeking at the object.

3 One by one, those in the seeing group describe the object to the listening group. Every person in the seeing group takes a turn to describe one aspect of the work in a single sentence. Each seeing person can say something about the object's subject matter, medium, or form, but does not reveal the artist's name or the title of the work. Take as many turns as necessary to fully describe the object.

4 Those in the listening group may not ask questions of the seeing group, except if they cannot hear what is being said.

(4a. Variation: Permit the listening group to ask the seeing group questions about the object, still without looking at it.)

5 When the seeing group thinks they have sufficiently described the work, the listening group is told that they can now turn around and see what has been described. This is a key moment for discovery for both groups: everyone should note any surprises they have when they first see the work.

6 After observing the work for a minute, the listening group tells the seeing group how well they described the object, noting any accuracies or discrepancies between the descriptions they heard and the object that they now

see. The listening group can then tell the seeing group their suggestions of what words might have helped them better visualize the object.

7 Switch roles for the two groups and repeat the exercise with a new object to be described and repeat the process.

Space for notes:

III. "Describing | Listening | Drawing"

This is an activity to be done in small groups of two, three, or four that teaches skills of describing and listening. One person describes an artwork while another draws that artwork by listening to the descriptions and without being able to see what is being described. Materials: smallish reproductions of artworks, drawing materials.

1 There are two parts to this activity: one part requires
 someone to verbally describe an artwork while the
 other part requires someone to draw the artwork as it
 is being described but without being able to see the
 artwork.

2 The instructor selects some reproductions of artworks
 to be used in this activity. The reproductions should be
 about postcard size or a little larger, museum postcard,
 or a page in a book. The instructor designates a person
 (or two or three) to be describer and another person to
 be a drawer.

3 The instructor gives a reproduction to the describer but
 the drawer is not allowed to see it.

4 Facing away from each other, the describer describes
 and the drawer draws what is being described until
 the drawing is finished. The drawer cannot see the
 reproduction and the describer cannot see what is being
 drawn.

5 When the drawing is finished, compare the drawing to
 the reproduction and discuss the describing part and the
 drawing part. Note successes and failures. Talk about
 what might have helped either party.

6 Share all the drawings with the whole group and discuss
 the challenges of the exercise and how to improve
 communication among describers and drawers.

Variation 1. Follow the exact procedures as above, but let the drawer ask questions of the describer during the exercise but the describer is still not allowed to see what is being drawn.

Variation 2. Do the same as above, but this time the drawer is allowed to ask questions and the describer is allowed to see the drawing as it develops.

Space for notes:

IV. "Be the mark"

This exercise is an inventive way to describe what you see. It asks you to note the importance of what you are describing by becoming aware of the power of all the parts, large or small, of a designed object or artwork. It also teaches that everything in a work is consequential, even if it is there accidentally. The exercise is mostly descriptive but partly interpretive: It is a kind of formal critique by way of inventing narratives based on what you see.

1 Select an object to explore. For example, you could choose Picasso's *Guernica*.

2 Then select one "mark" (shape, line, color, erasure, etc.) out of many marks in a nonobjective painting, one object in a representational work with many objects, or one color from a work with many colors. For example, you could choose to be the ceiling lamp in Picasso's *Guernica*.

3 Pretend you are the mark, the object, or the color.

4 Imaginatively become it. Identify with it. Empathize with it.

5 Then tell the story of your existence, how you came about, how you fit into the bigger realm that you are in, how you function, why you are important, and what would happen if you were no longer there.

6 Allow yourself to be playfully serious and write a very short and inventive story about you as if you are the mark, object, or color. Using first person singular might help you: "I am . . . and I arrived here when . . ." Write at least 50 words.

7 When you are finished writing and are ready to read your story aloud, first identify the mark, object, or color that you are, and read, or instead, first read your story and let others figure out who and where you are in the artwork.

Space for notes:

More ideas for descriptive critiques

The following ideas and suggestions are offered as additional material that can generate discussions of a general nature. They are offered by instructors from around the country and were written independently from the rest of the book.

•

To get students to really see everything about the works before we critique them, I have them draw each piece. Then we talk about the work. (Richard Harned, The Ohio State University)

•

Critiques with a Timer. Students bring their work with them to a circle of chairs. I instruct them to take their work and pass it to

the person to their left. I set a timer for 45 seconds. During that time the observer looks at the drawing. When 45 seconds have transpired, I quietly say, "pass" and we pass the drawings again to our left. We continue doing this until everyone has seen everyone else's work. Then I ask questions such as: "Did 45 seconds seem too long for some drawings or too short?" "Is your drawing able to maintain a viewer's interest for 45 seconds?" (Duffy Franco, Norwalk High School, Norwalk, CT)

•

After many years of teaching, I have come to use variations of the following instrument. The topics are to get the class group talking. Students talk about their:

1 Biography—geography, landscape of birth, familial and personal topography, dynamics of their family, friends, and people relationships;

2 Influences and affinities—these are what have and continue to shape their inner dialogues--these are mentors, influences, voices, materials;

3 Iconography, images and symbolism that sort of pop up in their work—these include color one never gets tired of or shapes that one can't get rid of and, of course;

4 Format, size, and materials one works with. (Hank Margeson, North Georgia College & State University)

5

Interpretation

When designers and artists make objects, those objects are expressive and will be and ought to be interpreted in addition to being described. They will be interpreted because people seek meaning. They ought to be interpreted because they offer meaning. This is true of both functional and nonfunctional objects: coffee cups, faucets, hammers, and hairdryers, as well as paintings, sculptures, installations, and video games.

One student recalls a critique in ceramics and enthusiastically supports interpretive critiques:

> We were able to look at and touch everything before we discussed it. The professor also mentioned the parameters of the project before we started, but did not make that a part of discussion. We talked about style, usefulness, aesthetics, and even a few political implications we saw in that group of works. It was awesome.

To interpret objects is to consider them carefully and to say what you think they express. You can identify what they express

to you by articulating your thoughts and feelings about the objects you see and otherwise sense.

To see something that was made and not interpret it is to miss its significance. There is much to interpret about objects in the realm of things made by humans. Artworks express attitudes and beliefs. Artworks also present ideas about the world and life. If you fail to interpret artworks you miss out on the unique contributions of artists and designers to the world of ideas and feelings.

To interpret is first to wonder. Without wondering interpretations will not follow. We wonder and interpret for ourselves. We seek meaning because we are naturally curious beings.

We interpret for others who are interested in expressive objects because we want to share our experiences and to feel connections with others. When you listen to the interpretations by other interpreters of the same object that you are considering you can match their thoughts with your own. If the two of you agree, you have reinforcement for your thoughts and feelings; if you disagree you can consider why, and perhaps adjust your thinking, or theirs, as a result of the divergence. You can learn about expressive objects and how they express and simultaneously learn about yourself and how you experience things, as well as learn about others.

You can raise and answer many different interpretive questions: What does this artifact mean to me? What does the object mean for others? How do the meanings that others articulate affect my immediate understanding of the object,

others, and myself? You can learn about yourself by knowing how you view an object similarly or differently than another. When you hear from other interpreters, you can expand your knowledge of the particular artwork being interpreted and also expand your knowledge of and deepen your sensitivity to people in the world.

It is often helpful to see expressive objects as opinions about life and the world. To interpret something made by a human you can ask and answer questions such as: What is this for and what is this against? Expressive objects are rarely if ever value neutral. What does this object promote and what does it discourage? Who is this made for? For what purpose was this made and what purpose does it now serve?

When you encounter expressive objects but do not consider what they are expressing and how, you are reducing those objects to the status of mere things instead of things that are made by intelligent, sentient beings. By not interpreting, you reduce the object of expression to mere lines and shapes, textures and colors that lack further significance. In a sense, you insult the object and its maker by not paying attention to what has been made.

By failing to interpret objects that express, you lose the intellectual and emotional content of those objects and we miss the contributions to the world of ideas and feelings that designers and artists offer. To offer interpretations of objects is to compliment their makers by paying attention and responding to what they have made. Interpretive responses are much more meaningful and satisfying to makers than responses such as "I like it."

How to interpret

You can obtain meanings of objects by using this formula: SUBJECT MATTER + MEDIUM + FORM + CONTEXT = MEANINGS. During descriptive phases of critiques, you can identify the people or objects or occurrences that are depicted in a work; in the interpretive phase, you can pay greater attention to intellectual, emotive, and attitudinal aspects of how the subject matter is depicted. Is the subject matter presented in a way that asks you to form a positive or negative response to what is shown? Are depictions of the work's subject matter ironic and presented with sarcasm? What indications in the work reinforce your understandings of how the maker has presented the subject matter? What ideas and beliefs does the object assert about the world?

You can examine the implications of the medium used in the work that you are interpreting. The huge, monumental, minimalist sculptures by Richard Serra are variously made of forged steel, weatherproof steel, and hot rolled steel. This information is descriptively factual; you can move this information into the realm of interpretive thinking by considering the effects of the different steels on your responses to the different sculptures. Does hot rolled steel express differently from weatherproof steel? Serra in consultation with his fabricators makes decisions about which kinds of steel to use and when. Interpret the effects of his choices on you: If one of Serra's steel sculptures is made to rust, how does this feature affect your thoughts and feelings about it?

A hammer displayed for sale in a hardware store appeals (or not) most likely because of its form: its shape, weight, length, texture, and choices of yellow, red, black, blue, and steel. The claw of a hammer is formed differently if the hammer is made for pulling nails or for ripping apart boards that have been joined together. The handles of hammers are available in wood, fiberglass, or steel. Handles come covered with leather, foam, and etched or smoothed wood. Hammers are available in weights of 16, 20, 22, and 28 ounces.

All of the factors that shape the look and feel of a hammer are significant, but the most significant is likely to be the contexts in which the hammer is to be used, or, its function. A hammer is a tool that is used to deliver a blow to an object: to drive nails or break apart objects. Is a particular hammer to be placed in a kitchen counter drawer, on a carpenter's tool belt, in a wood shop, at a construction site, or exhibited in a display case at the Museum of Modern Art?

Each of the aspects of subject matter and medium and form and contexts provide meaning but it is the combination of these aspects that yield the most complete and interesting interpretations. Subject matter alone, or medium or form or contexts alone, will not be sufficient to examine the many ideas, feelings, and attitudes expressed in a designed object.

Intentionalism and interpretation

Intentionalism is a theory of interpretation that asserts that a work of art means what the artist says it means, or what the artist

intends it to mean.[1] When used as a basis to judge the merits of a work of art, Intentionalism holds that an artwork is successful if it does what the artist meant it to do.

Critiques are often structured around Intentionalism. The artist is asked to state their intent in making a work and the discussion proceeds to examine whether that intention was met. Oftentimes the instructor has set the intent of the work through an assignment and the discussion follows as to whether the artist met the goals of the assignment.

There are advantages to using the artist's intent to determine what a work is about or if the artwork is good. An advantage of beginning a critique with an explanation by the artist is that it is an easy and seemingly common sense approach. It gets things started by giving the viewers a place to begin. Additionally, the artist gets to practice articulating in words what was made with colors, lines, and shapes. Faculties of higher education usually expect and request artists to be articulate speakers and writers about what they do as a condition of earning a degree. Granting agencies ask for artists' thinking about their own work as a prerequisite for awarding them funds. Gallery directors usually want to hear what the artist has to say and how it is said before accepting work for exhibition.

Often, especially in beginning and intermediate courses, the instructor has already set the intent for the project by giving an

[1] Beardsley, M. & Wimsatt, W. (1946). "The Intentional Fallacy," *The Sewanee Review*, (54)3, 468–488, https://american-poetry-and-the-self12.wikispaces.com/file/view/Wimsatt+%26+Beardsley,+Intentional+Fallacy.pdf (accessed 9 January 2018).

explicit assignment. It follows then that the instructor may well chose to run a critique to determine if the requirements of the assignment were met. The instructor usually dominates such critiques and critiques such as these are closer to being spontaneous lectures rather than interactive group discussions. This is okay. Such straightforward lectures can be direct, unambiguous, and instructionally helpful. During such critiques it helps if you know whether the instructor is inviting your ideas during these directly instructional sessions.

In upper level courses, student artists have usually decided their own intentions for a work or body of work, and your looking at the work may not immediately reveal the artists' intentions. Group discussions usually follow, sometimes with the artist first explaining the intent of the work, or the critique may begin with you trying to decipher the intent of the work and the artist only telling their intent at the end of the critique. You and the artist decide if the artist succeeded in expressing their intentions in the work itself. Each one of these methods can be useful and informative both for the makers and the viewers of objects.

Some limitations of Intentionalism

Intuitively and initially, Intentionalism sounds like a correct and common sense approach to deciphering meanings in works of art. However, asking artists for the meanings of their works is problematic. Is an artwork limited to the meaning that the artist

meant to convey? No. Certainly a work of art may mean differently than what the artist intended it to mean. It might mean more, or less, or something else entirely from what the artist intended.

Intentionalist critiques may miss or overlook meanings and expressions that are hidden from the artist such as subconscious impulses and desires. Effects may not be consciously intended by the artist but nonetheless show up in the work. During critiques when student artists hear about what others see in their work, or interpret their work to be about something that the artist had not intended, the artist often interrupts and says something like, "Oh, no. I wasn't thinking that at all," and derails what might be an interesting and informative conversation.

Because the artist was not trying to express something does not mean that it has not been expressed. It should not matter for interpreters if the implications of a work were not consciously intended. An expressive aspect of an object may have been "just an accident" as an artist might say, but nevertheless if it is there it can be and should be identified, discussed, and interpreted. If the item under interpretation can be seen in the work, it will and should count towards the object's meaning.

Interpreters sometimes worry that they are "reading too much into" the work, especially when the maker denies that such a meaning was intended. The danger, however, is reading too little into works, not too much. When an artist uses subject matter and medium and form within a context, the resulting object expresses whether or not the artist wants it to. Sometimes artists underestimate their own powers of expression.

In practice, when viewers see something significant in the work that the artist did not consciously intend, the artist may get self-conscious and deny what others can clearly see in the work.

Any chosen subject matter, medium, and form already come loaded with the influences of the culture in which it was produced. Objects also carry with them art historical references whether or not the artist is aware of them. Viewers will recognize such cultural and artistic influences and make meanings of them, whether or not the artist intentionally introduced those meanings.

An important objection to limiting interpretations to the artist's stated meaning is the belief that artists ought not, and cannot, control how the public sees and understands their work. Part of this belief is based on the idea that art works are not the kind of unambiguous objects that can be limited to definite meanings. Artworks are often open-ended and thus open to multiple interpretations. The second part of the objection is that when artists try to control interpretations, they take away the privilege and joy of interpretive processes from viewers. Furthermore, artists then miss hearing what the work means to others and might actually mean in itself.

Additionally, intentional critiques put the burden of interpretation on the artist rather than the viewers. Some hold that in meaningful engagements with art objects, there is a transactional endeavor between expressive artist and interpretive viewer to arrive at meanings. To ask the artist to make the work and also to interpret it for the viewer is to forget that meanings arise from the interaction of objects and many viewers.

Interpreting artworks rather than artists

When we interpret works of art, things and what they express, rather than the persons who made them, are the objects of interpretation. Too often in critical conversations remarks are made about artists: "She is just wanting our attention." "He is a business man disguised as an artist." Technically, in logical terms, such statements are *ad hominem*, the Latin term for "directed at the person." *Ad hominem* statements are logically fallacious because they direct attention to a person rather than to the artwork that is supposed to be discussed. In a critique you want to address thoughts and attitudes that are suggested, implied, or overtly stated in the expressive object.

Similarly, ethnic or gender designations may be considered *ad hominem*. Some artists of color, for example, wish to distance themselves in their artworks to matters other than race or nationality. Because someone is of a certain color does not determine that his or her art is also about color. It may be, or not, but attention to the object rather than the person is what is most relevant. A female artist does not necessarily make "feminine" or "feminist" art. Social and political positions and attitudes may well be seen in works of art, or suggested by them, but it is the works not the artists who are being interpreted.

A psychological reason to remove *ad hominem* statements from critiques is to lessen chances of artists feeling like they, rather than what they made, are being critiqued. It is the object not the person that is of interest in a critique. Making comments in the form of "it statements" rather than "you statements" will

lessen your chances of the artist feeling defensive about what he or she has made: "It seems to imply, by the use of the color blue, that the design is . . ." rather than "You are implying. . ."

Assessing interpretations

Interpretations of artworks are not the kind of thoughtful expressions that can be called "right" the way a mathematical equation might be called "right" or "correct." Interpretations are not statements of fact, they are strings of observations and thoughts that yield suggestions of meaning. Rather than "right," interpretations are said to be "convincing," (or not), "enlightening," "insightful," "meaningful," or perhaps best of all, "compelling."

Not all interpretations are equal: Some interpretations are better than others. They are more convincing (or not) because they better account for the times in which the artwork was made. They are more enlightening (or not) because they shed new light on artwork.

While artworks can yield many interpretations, artworks do not accept *any* interpretation. As Umberto Eco proclaimed, artworks have rights.[2] You cannot just make things up about artworks without respecting what the works actually show and how.

[2] Eco, U. (1992). *Interpretation and Overinterpretation.* Cambridge, England: Cambridge University Press.

You can measure the validity of an interpretation by applying three criteria to it: coherence, correspondence, and completeness.[3] Coherence: An interpretation ought to make sense *in and of itself* as a statement or narrative or an articulation of meaning. The interpretive sentence or paragraph should sensibly communicate on its own, alone, apart from the artwork. Does the interpretation itself make sense as an idea? Is the interpretive statement meaningful as a statement or is it contradictory or simply nonsensical? If the interpretive statement is incoherent it is not useful and can be put aside.

It is not enough, however, for the interpretation itself to make sense. For the utterance to be a good interpretation it must make sense in itself but also, very importantly, it must correspond to what can be seen or otherwise sensed in the work of art. You have probably heard an interpretation that sounds good but yet just does not seem to fit the work it is supposed to be explaining. When this is the case, the interpretation lacks sufficient common touching points with what can be seen in the artwork, and the interpretation can be deemed faulty.

Finally, in addition to the interpretation being coherent in itself and correspond to the artwork, sufficiently matching what can be seen in the artwork, the interpretation must also account for all the important elements and aspects of the work being interpreted. If the proffered interpretation does not reasonably account for the subject matter, the medium, the form, and the

[3] Hirsch, E. D. (1973). *Validity in Interpretation*, New Haven, CT: Yale University Press.

context of the work, it lacks completeness and is an inadequate interpretation.

Principles of interpretation for critiques

- Artworks are always about something.

- SUBJECT MATTER + MEDIUM + FORM + CONTEXTS = MEANINGS

- To interpret a work of art is to understand it in language.

- Feelings are guides to interpretation.

- The critical activities of describing, analyzing, interpreting, judging, and theorizing about works of art are interrelated and interdependent.

- Artworks attract multiple interpretations and it is not the goal of interpretation to arrive at single, grand, unified, composite interpretations.

- Some interpretations are better than others.

- There is a range of interpretations any artwork will allow.

- Meanings of artworks are not limited to what their artists meant them to be about.

- Interpretations are not so much right, but are more or less reasonable, convincing, informative, and enlightening.

- Good interpretations of art tell more about the artwork than they tell about the interpreter.

- The objects of interpretations are artworks, not artists.

- All works of art are in part about the world in which they emerged.

- All works of art are in part about other art.

- Good interpretations have coherence, correspondence, and completeness.

- Interpreting art is an endeavor that is both individual and communal.

- The admissibility of an interpretation is determined by a community of interpreters and the community is self-correcting.

- Good interpretations invite us to see for ourselves and continue on our own.

Interpretive critiques to try

I. "Everything counts: When I see x, I think y"

This critique teaches the importance of every decision that the artist makes: Everything counts in a work of art. It also teaches that everyone can contribute something of import to a critique: Everyone has a voice that counts.

1 Situate the group in front of or close to the artworks up for critique so that everyone can see them clearly and hear one another speak.

2 Select an object on display to begin with. Then, one by one, each participant, including the person who made the object, names one thing in the object that they notice and says what they think of when they notice it. Take turns in an orderly manner, moving from left to right, clockwise, or some other system. Move along quickly. Limit each remark to one thing only. Make sure everyone can hear what has been said and knows which thing or aspect is being noticed. Use this prompt for every turn and make each statement a full sentence: "When I see _____, I think of _____." Example: "When I see the mother holding her dead baby in Picasso's *Guernica*, I think of the pain caused by violence."

3 Repeat this process of everyone naming and noting something different at least three times, if you are able. Any single item in any object may be noted more than once if the thought that it prompts is different from what has already been said.

Variation: If there are many works of art to be critiqued during the session, instead of dwelling on different items in a single work, make a single comment on each one of the works on display. Move in an orderly fashion from work to work, perhaps left to right. Make sure each work gets three comments or more,

depending on the size of the group, the amount of artworks, and time allotted for the critique.

Space for notes:

II. "Feelings matter: When I see *x*, I feel *y*"

This exercise recognizes the importance of feelings when responding to works of art and objects of design. It encourages viewers to allow themselves to feel and to express those feelings. Such expressions of feelings will provide important information for the one who made the object.

1 Situate the group in front of or close to the artworks up for critique so that everyone can see them clearly and hear one another speak.

2 Select an object on display to begin with. Then, one by one, each participant, including the person who made the object, names one thing in the object that they notice and says what they feel when they notice it. Take turns in an orderly manner, moving from left to right, clockwise, or some other system. Move along quickly. Limit each remark to one thing only. Make sure everyone can hear what has been said and knows which thing or aspect is being noticed. Use this prompt for every turn and make each statement a full sentence: "When I see _____, I feel _____." Example: "When I see the mother holding her dead baby in Picasso's *Guernica*, I feel anguish."

3 Repeat this process of everyone naming and noting something different at least three times, if you are able. Any single item in any object may be noted more than once if the feeling that it prompts is different from what has already been said.

Space for notes:

III. "An interpretive critique based on artistic intent"

This critique is designed to help artists and designers be articulate in their talk and writing about what they make. It also requires that their verbal intentions match their visual works or vice versa. Some artists make good works but are not able to adequately express themselves in words; other artists are good with words but their words do not sufficiently match their works. This exercise is meant to strengthen both making and writing or talking.

1 An artist writes a brief one-paragraph statement of intent for their artwork. Using complete sentences, continue from this prompt: "I want my piece to express . . ."

2 The artist reads the intent slowly and loudly to the group. Ask the artist to read the intent twice, if necessary, for audibility.

3 The group of listeners then discusses the written statement of intent without talking to the artist and without matching it to an artwork.

4 The whole group, with the artist only listening and not interjecting, discusses the written intent asking and answering the question: "Does the written statement make sense *in in itself* apart from the artwork?" The artist is not permitted to make comments on what they have already written and the group does not ask questions of

the artist. The artist listens carefully and takes notes for later use.

(4a. Variation. If this is the first time doing this exercise and the written intent is not adequate (perhaps too vague or ambiguous, contradictory, not in sentence form) let the artist revise the intent in writing, and repeat the process at a later time.)

5 The artist then identifies the artwork(s) to be critiqued and reads the intention again, without explaining further.

6 The group matches the intent and the artwork by examining these questions: 1) "Do the words match what is seen in the work, suggested by the work, and sustained by the work?" 2) "Can or does the stated intent include all important aspects of the work?" If the group finds significant differences between the written intent and the artwork, they answer this question, 3) "What might be needed to have the stated intent and the visual artwork better match one another: the statement, the work, or both?"

7 Throughout the discussion, the artist merely listens, takes notes, and then later decides what if any changes to make to the artwork, the written intent, or both.

Space for notes:

IV. "Coherence, correspondence, and completeness"

This critique exercise is meant to benefit both the artist whose work is being critiqued and those engaging the work interpretively with thoughts and feelings. In the preceding chapter, the criteria for a well-articulated interpretation are said to be the coherence of the interpretation itself, its correspondence to the work in question, and its completeness in covering all aspects of the work.

1 Select the artworks to be critiqued. Examine them carefully and close-up.

2 Either in small groups of two or three or individually, first describe all the aspects of a work: its subject matter, medium and how the medium is used, its form, and

consider the context in which it will be seen. Your standard here is completeness. Have you covered everything in the work?

3 Then write what you think is a sensible interpretation of what the piece expresses, or how it functions as a utilitarian object or space: "This work seems to be about..." Use complete sentences that make up at least one paragraph. Check your written paragraph of interpretation of the piece and see if it makes sense in itself (coherence).

4 Then examine the work again and match your written statement to the work to see if the writing corresponds to what can be seen and felt in the work (correspondence).

5 Does written interpretation adequately account for the work (completeness)?

6 If there are mismatches in any of the three areas of coherence, correspondence, or completeness, make adjustments as best you can to your writing. Be generous in your thinking and try to give the work what you think might be its best interpretation.

7 Present your interpretation to the artist and the whole group of viewers. Open a discussion by asking some of these questions: "How well or not do the interpretation and the work fit together?" If there are not good matches between the two, "Where might the problem be: with the interpretation or with the artwork or both?" "What does the artist think of the interpretation? Would the artist make changes to either the interpretation or the work?"

Space for notes:

More ideas for interpretive critiques

I sometimes use four types of questions concerning:

1) the objective, raw data level, that which first strikes the visual sense;

2) the reflective level about compositional qualities;

3) the narrative level about clear or obscured, intentional and unintentional messages; and finally, I ask

4) what shifts in thinking about this work have occurred? (Bill Benson, Professor Emeritus, University of Wisconsin at Eau Claire)

•

Borrowing from Umberto Eco's essay, "Reading My Readers," I ask my students to choose one of three responses about what has been said about their work:

1) I created the work and know what I intended and your reading of my work is in keeping with my intentions;

2) I created the work and know what I intended and your reading, although different from my intentions, is a plausible interpretation;

3) I created the work and know what I intended and I cannot accept your reading of my work as plausible.

A good discussion of subject matter, form, and meaning usually follows. (B. Stephen Carpenter II, Penn State University)

6

Judgment

Judgments about art are statements of value answering two big questions: 1) What is the value of art and 2) is this particular piece of art good? To answer the first question is to engage in philosophy of art, aesthetics, or art theory: "Art is good because …" To answer the second question in a responsible manner, you have to make a claim of merit, offer reasons for your claim, and ultimately base your reasons on bigger reasons, namely, criteria. This is an example of a judgment with three constituent parts: "Picasso's *Guernica* is an excellent work of art" (claim of merit) "because it arouses strong emotions in response to a horrific act of violence" (a reason to back up the claim of merit) "and art that awakens us to needless human suffering is good art" (a statement of criteria).

This chapter is written to show how to expand and deepen statements of judgment. Too often critiques begin and end with simple statements about specific works of art such as, "I like this one" or "This one works." The common comment of "I like this one" is not even stated as a claim of merit: It is a statement of

personal preference that says that the viewer likes something but it does not say if that something is good. The statement that "This one works" is a statement of merit but it says too little because it does not offer reasons for how or why the object "works."

The realm of values

Values are standards, ideals, convictions by which we judge things, people, actions, and situations. Values and beliefs drive all of our intentional actions whether or not we are aware of them at the time of taking an action or making a decision. There are many kinds of values: personal values, family values, cultural values, monetary values, moral values, religious values, and artistic values. Values can be further distinguished by whether they are considered to be pragmatic and temporal, intrinsic or instrumental, or eternal and universal.

Many people embrace values such as spontaneity, tolerance, vitality, success, strength, serenity, reliability, generosity, happiness, humility, ingenuity, social status, honesty, joy, love, mastery, honesty, expressiveness, beauty, curiosity, empathy, elegance, diversity, unity, dynamism, athleticism, diligence, dependability, control, discipline, freedom, consistency, community, cheerfulness, and so forth. Some people identify negative values to be avoided such as sloppiness, loneliness, lethargy, poverty, rigidity, misery, hostility, embarrassment, cynicism, despair, and so on.

The artistic theories that the collective artworld of the West has offered over time are Realism, Expressionism, and Formalism.

Realism that we inherit from the Ancient Greeks asserts that art or an artwork is good because it portrays people and things that are true and beautiful in truthful and beautiful ways. An artwork ought to look like what it is meant to show. Art should show aspects of nature and life at their best or as they could be in their ideal states. Realism for the Ancient Greeks is a means of visualizing and inspiring perfection.

We inherit Expressionism from German poets and artists at the beginning of the nineteenth century who asserted that art or an artwork is good because it vividly evokes thoughts and emotions in viewers. Good art shows powerful emotions and evokes these emotions in viewers. Good art is also a special way of knowing and presenting the world. It does not need to be realistic but must evocatively affect those who see it.

American artists and art critics in the mid-twentieth century brought us Formalism, a theory that asserts that art or an artwork is good because it frees us from mundane concerns about the trivial by showing us elegant abstract form. All art has form but Formalist theory holds that form is the only significant factor in judging art. Formalists hold that good art need not be realistic, ought not be politically driven, and that narrative content is distracting from the import of the work's form. Further, they believe that good art is independent of moral standards.

Postmodernist art theory of the late-twentieth century and early-twenty-first century challenges prior theories about what is good art and asserts that no single theory holds true anymore. Postmodernist theory rejects traditional notions of beauty and questions the veracity of truth, the two foundations of Realism.

Postmodernist theory questions the Expressionist notions of artistic genius and doubts the possibility of originality. In opposition to Formalism, Postmodernism holds that art should be receptive to daily visual culture and be more concerned with issues of everyday life. Postmodernists minimize or ignore supposed distinctions between high and low, fine and popular art.

Theories of art

Criteria are specific statements that we generate from more general values about the goodness or merit of an artwork or designed object. (*Criterion* is singular, *criteria* is plural.) Synonyms for criteria are standards, norms, measures, tests, barometers, rules, laws, and cannons. Criteria are "shoulds": "Good art should . . ." We derive specific criteria from general values.

> I live and love design.
> It's a joyful process.
> It's striving to find
> Clarity—scraping off the superfluous.
> Finding the gem.
> It's simple. It's clear.
> It's beautiful.
>
> Justin Plunkett

[1] Plunkett, J. (2017), Justin Plunkett, http://www.justinplunkett.com (accessed 28 August 2017).

A designer of products and graphic communications wrote the statement of criteria above and intentionally mixes moral values and artistic values. He combines the moral values of love, clarity, enjoying process and striving with the artistic values of simplicity and beauty.

Two longstanding theories of art, Realism and Expressionism, continue to provide criteria for good art. A mirror and a lamp are two common metaphors for Realism and Expressionism that derive from literary criticism authored by H. A. Ayers.[2] According to Ayers, a Realist work of art should be a mirror that accurately reflects the real world; for an Expressionist, an artwork should be less like an exacting mirror and more like a shining lamp that illuminates the world through the sensibilities of the artist. With a similar intent of making clear some distinctions between Realism and Expressionism in photography, John Szarkowski curated a show and catalogue in 1978 that he called "Mirrors and Windows."[3] In Szarkowski's metaphors, a photographic mirror shows more about the photographer than the world while a photographic window explores the world as it exists apart from the photographer making the picture. Ayres's mirror gives aesthetic credit to the awesome world as it exists, and his metaphorical lamp shines upon the creative artist more than on the physical world; Szarkowski's metaphoric mirror, however,

[2] Abrams, M. H. (1971). *The Mirror and the Lamp: Romantic Theory and the Critical Tradition*. NY: Oxford.

[3] Szarkowski, J. (1978). *Mirrors and Windows: American Photography since 1960*. NY: Museum of Modern Art.

privileges the artist and his window moves attention away from the artist toward the glory that is physical existence. These different metaphors may be confusing at first but are informative about criteria for judging art: Should artists respect and honor and recreate what is already there or should they investigate and work their unique sensibilities and insights and make art their personal expressions?

A painter upholding and implementing Realism as a theory for what makes art good might assert the criterion that "A good painting should draw more attention to the beautiful subject matter in the world rather than to the ability of the artist who made the painting." Contrarily, an Expressionist painter might assert that "It is not enough to replicate aspects of the world, a good painting should show us the artist's unique sensibilities in response to reality."

A painter adhering to Formalism, however, would likely assert that "Representation is irrelevant to art and a good painting is about form itself, not about subject matter." Formalism asserts, primarily, that art should be about form, not about the physical world or the emotional state of the artist. Realists believe that form should be in the service of celebrating the natural. Expressionists believe that form is in the service of moving the viewer's emotions.

The theory of Formalism is at odds with competing theories concerning a central question of the purposes of art. The question can be posed in different ways. Should good art be a means to an end or is good art an end in itself? Is good art intrinsically valuable or should art be in the service of other goals? Some

assert that good art should further instrumental goals such as eliminating social injustice. Formalists, however, insist that art is an independent realm of human existence and that it need not and should not engage in anything but its own unique aesthetic magnificence. Realism, Expressionism, and versions of Postmodernism hold that art is and should be instrumental, and at the least offer some meaningful and motivational insight into the current condition of the world.

Modernist criteria for art and design

Designers and artists generally uphold craftsmanship as a value in art and design with most believing that an object ought to be well made. What is well made will differ according to object, function, and context. A well made fresco will adhere to the wall on which it is made, will retain its color over time, and meet other physical requirements. A well-designed interior space will not endanger its occupants. A well-made ephemeral sculpture made of ice out of doors will hold together in freezing temperatures but will not be expected to last through different seasons of the year. Each of these examples of valued craft is specific to an imagined piece: No universal criteria for good craft are set forth, rather they are dependent on purpose and context of the object. "Well-crafted" in these cases might be more accurately termed "appropriately-crafted."

Values we tend to uphold in artistic behavior are creativity, inventiveness, perseverance, and hard work. Values we tend to

hold for art objects include craftsmanship in the absolute or craftsmanship to suit an artistic purpose, visual appeal, and fresh approaches to ideas and themes. Negative artistic values can include lack of originality, copying, visual clichés, and sloppy workmanship unless done for an intended effect.

Many of the artistic values that are commonly applied to works of art and design are referred to as "principles of design," first articulated by Arthur Wesley Dow in 1899 in the United States. Principles of design vary according to the instructor using them, but this list is representative: directional force, proportion, balance, contrast, repetition, unity, variety, emphasis, and subordination.

Directional force is an artistic criterion that asserts that a composition ought to have a primary directional emphasis, usually contrasted by a secondary emphasis. Landscapes generally have strong horizontal direction, perhaps accented by a vertical element in the composition. Traditionally, horizontal emphases are calming, diagonal emphases are energetic, vertical emphases express strength and stability, and circular directions express fullness.

Artists and designers often attend to **proportion** in their compositions, seeking satisfying or expressive relationships of different size elements to one another. The size and scale of elements in the composition are subordinate to successfully expressive proportion.

Concern for **balance** is often a criterion used to judge compositions. Balance is equilibrium of weight and force enabling a composition to remain upright and steady. Lopsidedness in

spaces, objects, and images is generally undesirable. Balance can be actual, visual, or both. Balance is a particularly important criterion for three-dimensional objects or structures. Poorly balanced structures can topple and cause harm.

Contrast is a criterion by which to measure the juxtaposition of elements in a single design such as light and dark tones, warm and cool colors, or conflicting ideas such as war and peace. Visual contrast is the degree of more noticeable or less noticeable visible differences among elements. Conceptual contrast is an implied opposition of ideas to emphasize maximal or minimal differences.

Repetition is a criterion that asks for the use of any element more than once in an art object to add unity to its design. Repetition often provides viewers or users with some comfort of continuity. Visual rhythm is an additional and related criterion that asks for some kind of ordered arrangements of elements in a composition or object.

Many artists believe that a composition ought to have both **unity and variety**. Unity implies oneness and harmony and the feeling that the image or object holds together visually. Too much unity, however, may result in visual monotony, thus variety is a counterpart criterion to guarantee some diversity in the object or image. Unity lets the viewer see the artifact as a whole while variations hold their interest.

Emphasis and subordination are criteria related to unity and variety. The criteria of emphasis and subordination should together assert a visual hierarchy of elements to support a larger idea or visual motif. One or more elements should dominate and another or others should be designed to be subordinate.

Emphasis focuses viewers' attention and subordination support the major theme or idea of the object.

Artistic values change. Originality was an especially honored artistic value in mid-twentieth century Western art: An artwork had to be different from its predecessors; an artist should not be too derivative; artists should not copy others' art. Postmodernists, however, question whether originality is even possible and argue that all artists are culturally conditioned by what they see and have seen. In pre-Modern times, originality was looked down upon: traditional cultures wanted traditional representations of sacred imagery, not innovations.

Postmodernist criteria for art and design

Whether you are consciously aware of it or not, you have been living in an era of art called postmodernism. During your education as an artist, you have almost certainly been influenced by modernism and postmodernism because the two eras overlap and one is known only in light of the other. Postmodernism is generally said to have a beginning in the 1960s. Postmodernism is dependent on modernism, lives alongside it, and challenges it.

In 2004, Olivia Gude, muralist and art educator, identified these postmodern principles of design: "appropriation, juxtaposition, recontextualization, layering, interaction of text and image, hybridity, gazing, and representin."[4] These principles

[4] Gude, O. (2004), "Postmodern Principles: In Search of a 21st Century Art Education," *Art Education*, (57)1, 6–16.

can serve us here to distinguish and identify some of the practices of our art making lives.

Perhaps the most significant transformation from modernism to postmodernism is artists' rejection of the value of originality. In premodern times artists were anonymous contributors to their communities. In modern times values shifted and the individual artist came to be honored as a champion of authentic and free personal expression. Postmodernists question the concept of originality in art and they are doubtful of the possibility of being original. They claim not to hold originality as an artistic value and in its place value appropriation.

Appropriation: To appropriate is to possess, borrow, steal, copy, quote, or excerpt images that already exist and are available in the public domain and in general culture. Appropriation purposively challenges the criterion of originality as unattainable; it also demystifies the artist as an individual genius, encourages artistic collaboration, and asserts that all art is highly influenced by other art and culture in general. Jeff Koons has appropriated Popeye, Michael Jackson, and Hummel figurines from popular culture for different expressive purposes.

Juxtaposition: To juxtapose is to bring together into one work of art clashing images, ideas, and sensibilities or random associations to make comment on shocks of contemporary life. Juxtaposition deems the Modernist criterion of contrast insufficiently mild. In his installations and performance pieces, Paul McCarthy juxtaposes popular notions of innocence with topics considered impolite in civil conversations. His chosen media include common foods such as mayonnaise, ketchup, and

chocolate sauce to stand in for semen, blood, and excrement. In a pencil drawn study for a large sculpture, McCarthy poses Pinocchio on a toilet: *Pinocchio Pipenose with Donkey Ears on a Toilet* (1990).

Recontextualization is a common postmodern strategy of putting familiar objects into new contexts to generate new considerations. Fred Wilson is a contemporary master of recontextualization. For his exhibition *Mining the Museum* (1993), the artist foraged through the permanent collection of a historical museum in Maryland and then put side by side a wooden post for whipping slaves and finely crafted furniture made at the same time. He also recontextualized silver tea sets by showing them alongside steel shackles made for slaves, to showcase the brutality that coexisted with gentility.

Layering is a postmodern practice of putting images on top of one another to create awareness or make a statement. Yolanda Lopez painted a self-portrait that pictures her as both Our Lady of Guadalupe and as a svelte and sexy runner wearing tennis shoes. With the image she hopes to challenge a common ideal of a woman in Chicano culture.

Combining **text and image** is common practice in graphic design, especially for the advertising industry. Barbara Kruger a postmodernist with experience in graphic design for commerce turned her knowledge and skills into making works of protest to be shown in art galleries and on tee shirts and other common items. In *Untitled*, (1986), Kruger appropriated a black and white photograph of a mushroom cloud and superimposed on it the words YOUR MANIAS BECOME SCIENCE. When she

makes the same image for languages other than English, she changes the text to read "their manias become science," linking destructive power with craziness and violence under the guise of science to the United States.

Hybridity refers to the practice of recent artists mixing different cultural influences into their pieces. Artists disrupt and make more complex cultural generalities such as high art/low art, fine art/popular culture, male/female, black/white, masculine/ feminine, and gay/straight. Takashi Murakami, Japanese artist of international repute, has a prolific output of art and merchandise, such as his product collaborations with fashion designer Luis Vuitton and his musical collaborations with Pharrell Williams. Postmodernists in particular value hybridity and question notions of essences in favor of what they believe to be the interdependent nature of knowledge and expression.

Gazing: In his book and TV series *Ways of Seeing* (1972), British art critic John Berger identified "the male gaze" as one with which art and advertising typically show men acting and female appearing, men looking at women and women watching themselves being looked at. He asserted that men picture women for male pleasure. Artists who work with the theme of the gaze critically ask who is representing whom, how, by what means, and to what effect. Cindy Sherman has built a large collection of photographs of herself as the subject matter: Although she is the subject matter, her subject is the gaze, or how women are variously portrayed in art and daily culture. Gazing is a strategy of resisting the male gaze by calling attention to it, by adding a female gaze, and by showing the gaze of underrepresented people.

Representin' is a term that Gude appropriated from urban street language to proclaim one's identities and affiliations. The term refers to artists of various cultural and ethnic backgrounds actively re-presenting themselves as they want rather than passively accepting how they have been represented by a dominant and often colonizing culture. Representin' is the constructing of new identities that empower the voices of those marginalized by dominant discourses and narratives circulated in general culture.

Another desire for making art in postmodern times not identified by Gude is **simulating the real.** In contemporary society, there is mistrust of "the real" because of more or less convincing portrayals of the unreal by artists and producers of images, supposed facts, and fictions that are presented as true stories. Computer based imagery and lens based imagery lend themselves to very believable simulated experiences that add to disbelief or try to fight against it. Gregory Crewdson is a contemporary photographer who makes large-scale color photographs of fictitious situations that could very well be real but are not. Simulations of the real in art media are similar to occasions and discussions of "fake news" in mass and social media during the Donald Trump political era.

Further considerations of appropriation and originality

To appropriate is a postmodernist strategy of intentionally borrowing in a provocative way. Picasso and Braque incorporated

pieces of actual newspapers onto painted oil canvases, creating what is now known as collage, and later Marcel Duchamp's exhibition of found objects such as a urinal as a work of art, root the tactic of appropriation in early twentieth century art history.

More recently Sherrie Levine photographed and exhibited a reproduction of a historically significant art photograph made by Walker Evans, *After Walker Evans: 4*, (1981), which became part of the permanent collection of the Metropolitan Museum of Art in 1995. Levine's appropriation of Evans's work is more than a "high-concept cheap shot":[5] It is one of Levine's many paintings, sculptures, prints, and installations that Levine has made over the past thirty years. Her works are icons of Postmodernism that are critically praised and attacked as feminist challenges to patriarchal authority, the commodification of art, and Modernist ideas of originality, authorship, and male dominance in the history of art.

Layering, recontextualizing, hybridity, culture jamming, hacking, sampling, culture jamming, mixing, and the making of mashups are all strategies of appropriation that are used today in music and visual art. Each strategy utilizes the blending and reconfiguring of preexisting images, objects, and sounds to create something new.[6] These strategies are all forms

[5] The Met, "After Walker Evans: 4," https://www.metmuseum.org/art/collection/search/267214 (accessed 10 December 2017).

[6] Griffin, K. (2016). "MashUp looks at how a gesture in the studio in the early 20th century influenced today's visual and aural culture," http://vancouversun.com/news/staff-blogs/mashup-looks-at-how-a-simple-gesture-in-the-studio-influenced-todays-visual-and-aural-culture (accessed 12 December 2017).

of appropriation and are common in the artmaking of today.

It is important to distinguish between Postmodernist appropriation and plagiarism. Plagiarism "is the act of using another person's words or ideas without giving credit to that person" and to plagiarize is "to steal and pass off (the ideas or words of another) as one's own."[7] Appropriation is one of many accepted, and sometimes contested, Postmodern strategies for making; plagiarizing is a crime and can result in your expulsion from school. To take a logo, for example, from someone and to pass it off as your own in a design course is wrong.

Copying is different from both appropriation and plagiarism. To copy an Edward Hopper painting, for example, may be a means of learning to make a painting by carefully examining another painting. However, to copy another student's work and pass it off as your own is plagiarism.

All artists are influenced by seeing or having seen the work of other artists. Acknowledging the influence of another artist in your own work is to be complimentary to that artist so long as you admit the influence. Graduate students who write Master's theses are often asked by instructors to acknowledge the influences as an expected and normal part of writing about their development as artists.

Postmodernists question the idea of originality and even its possibility. They see all works of art as "texts," that is, cultural

[7] Merriam-Webster, "Plagiarism," http://www.learnersdictionary.com/definition/plagiarism (accessed 10 December 2017).

products rather than the creations of individual makers. In studio critiques, however, originality in its ordinary sense of your work being more or less innovative, showing something new or something in a new way, and eventually having a style of your own. If there is nothing fresh or different in your work it will likely be considered stereotypical, clichéd, too derivative, or simply copied.

Preferences and values

In critiques, participants too frequently confuse preferences with values. To say that you like something is only to say that you prefer it, but it is not to say that what you prefer is good. You just like it.

To state a preference is to provide others with an aspect of your psychological makeup. If you happen to like blue and violet more than green and yellow that does not necessarily mean that you think blue and violet are better than yellow and green. If you like pie more than cake that does not mean that you necessarily think one is better than the other. You just like one more. If we hear enough of your preferences, we will get to know you better, but generally, during critiques, we are trying to get to know that artwork better. Preferences are about individuals; values are about objects, ideas, and occurrences rather than the individual who holds them.

We defend values but we usually do not feel the need to defend preferences. If you say you like chocolate ice cream more than

strawberry you do not have to defend your choice. A likely response might be "Oh," rather than "You're wrong." However, if you assert that a picture of dogs playing poker is better than William Wegman's photographs of dogs, you will likely be asked to defend that statement with reasons. It is more than you like kitschy things found in discount stores; it is that you think they are better than artworks that are collected in art museums. Of course you have every right to hold such a position but you should know that you would likely be asked to defend that position with some logical reasons whereas you will likely not be asked to defend your preference for chocolate over strawberry ice cream.

In popular culture we hear the phrase "beauty is in the eye of the beholder." This assertion is valuable in the defense of personal preferences about what you like to see but it does not hold true for judgments of value about works of art. In disagreements about artist value, (you say it is a successful work of art, I say it fails), some assert that such opposing differences do not ultimately matter because "it's all subjective anyway." Artistic values are not subjective they are inter-subjective. That is, artistic values are determined by many different individuals who concur about what should be valued and not. Such collective decisions ultimately result in collections of art that are held, honored, and defended by the artworld and those people who make, study, collect, and distribute art. They may not all agree on the value of a specific work of art, but they generally concur that such disputed objects deserve to be preserved and debated.

The distinction between preferences and values is liberating. Ideally, we would prefer what is good. However, you get to like what you want: You can like what is not good and you can dislike what is good. You might well prefer a TV soap opera to Shakespeare's *Macbeth*, but ideally, as an educated person, you would understand why *Macbeth* is better literature than the scripts of *The Young and the Restless*.

Selecting criteria for judging art

Given the many criteria identified in this chapter, when consciously deciding to judge a work of art, which criterion will you choose? If you choose one, will you apply it to all works of art and judge them to be successful or not according to the single criterion? Some professional art critics adhere to a single criterion for all works of art, ignoring works that do not meet their criteria or give us reasons for judging those works as failures or "not good" for art or for society. Likewise, some instructors of art adhere to single sets of criteria, and so do some schools.

If you choose more than one criterion, which ones will you choose? Will you weigh them equally or will some be more important to you than others? Some different criteria can be combined coherently but other criteria contradict each other. Will you hold contradictory criteria?

In critiques, sometimes the instructor chooses the criterion or criteria for judging the work being shown. Often criteria are the bases for grades that are usually assigned by the instructor. It

might be helpful to ask to explore which criteria the instructor holds for a particular course, assignment, or critique.

Sometimes the artist chooses by which criteria they would like their artwork to be judged. If those participating in the critique adhere to the artist's request for the use of selected criteria, the conversation may move without debating criteria and the task will be to see if the work matches those criteria selected. The range of the discussion in such critiques will be limited by the selected criteria. A limited range may be constructive or too narrow.

Often, Instrumentalism is employed to judge the value of works of art: The intent of the artist is x, the artist's work of art meets that intent, and therefore is a good work of art. Problems arise. Can a work of art be successful if the artist did not intend it to be the way it actually is? Probably yes. Can a work of art be meritorious if it shows something different from what the artist intended? Probably yes. Can a work of art be "good" if it is based on a "bad" intent? Probably no.

Sometimes the artwork "asks" to be judged by a certain criterion. If you walk into a one-person exhibition, and if the work has some consistency, it will "tell" you how it would like to be seen and judged. You can go with this "request" or ignore it and impose your own criterion.

A general recommendation here is to be open and flexible about criterion. Try on a single criterion for all art and see how it fits your beliefs and how it fits the works. Will this single criterion be too narrow and exclude too much art? Is your single criterion too vague that it fits all works but does not help you much in

determining relative merits of different works? You can discover a criterion's strengths and weakness for you as an artist, for you as a viewer of art, or as if you were the art instructor.

Principles of judgment for critiques

- APPRAISALS + REASONS + CRITERIA = JUDGMENTS
- Judgments are different from preferences.
- Judgments, interpretations, and descriptions are interdependent.
- Judgments, like interpretations, should be persuasive arguments.
- Some judgments should be taken more seriously than others.
- Judgments consist of appraisals with reasons in support of those appraisals.
- Judgmental appraisals and reasons are based in criteria.
- Some criteria can be combined while others are mutually exclusive.
- Solid judgments depend on accurate descriptions and informed interpretations.
- Feelings influence judgments.
- Works of art, not artists, are the objects of judgments.

- Judgments, like interpretations, are communal decisions, and the community is self-corrective.

- Judgments, like interpretations, should be personal as well as communal.

- Judgments should tell more about the work being judged than about the person doing the judging.

- Judgments of artworks are usually based on worldviews broader than aesthetic views.

- Different judgments are beneficial because they highlight different aspects of artworks that we might otherwise overlook.

- Judgments, like interpretations, should invite us to decide for ourselves and continue on our own.

Judgmental critiques to try

I. "Ratings without reasons"

This particular critique requires everyone to make a judgment of every artwork on display. It is a particularly good initial exercise if you are not yet comfortable with making judgments, especially judgments about your fellow artists' works. It is also an exercise to build critical communities of support. One easy option in the exercise is to give everyone's artwork the highest possible rating. If you do this, however, you will probably not have exercised honesty or faced the discomfort of making judgments that may not be completely positive. Ultimately and ideally during an art

course all in the course will be able to eventually function as a supportive yet critical community of artists.

1 Have one small blank Post-it note for every object to be critiqued. Write your name on each note.

2 Carefully view the selection of objects to be critiqued. Examine them closely.

3 Give a rating from 1–10, 10 being the highest, for each of the artworks on display. Place your note next to the artwork you are rating. Rate all of the works except your own.

4 Sit back and observe while everyone completes the task.

5 Quietly reflect on the experience of judging the artworks, not on the works themselves.

6 Break up into small groups of four or five. Have a discussion in your small group about your individual experiences. Was rating all the artworks easy or difficult to do? Why? Were you comfortable or uncomfortable? Why? How do you feel when seeing how others rate your artworks? How do you feel when rating others' artworks during critiques? What did you learn about yourself in this experience? What might you need to work on to continue to more comfortably work in critical group critiques?

7 Share some of the findings from your small group with the whole group.

Space for notes:

II. "Ratings without reasons II"

This critical exercise charges you with distinguishing between best, next best, and least best works of art. It is meant to make you take a stance, especially if you find it difficult to do so. The use of colored notes will also allow you to quickly see patterns of placement of the choices made about the works of art.

1 Have three different colors of Post-it notes. Designate one color for best, another color for next best, and the third color for least best. Put your name on all three of your notes.

2 Carefully examine the objects to be discussed in the critique.

3 Use all three of your notes, putting each next to different objects.

4 Sit back and reflect on the dispersion of the color notes. What was your experience in using all three notes, from positive to least positive? Was it difficult or easy? Why?

5 Discuss your experience with the group.

6 Then consider how the colors are placed throughout the collection. Is there general consensus? Is there obvious disagreement? Does a single object receive both most good and least good from different participants? What conclusions can you reach regarding the placement of colors?

7 Discuss the results of the group's judgments.

Space for notes:

III. "Ratings with reasons"

This critique requires that you rate different artworks and also provide reasons for your ratings.

1 Write your name on Post-it notes, one for each work on display. Use white notes or a single color for everyone.

2 Carefully observe each of the works displayed for the critique.

3 On one note for each work of art, choose a rating from 1–10, 10 being highest. Write a reason for your rating in a single sentence. Do not use one-word reasons. Place your note next to the artwork you have judged.

4 After everyone has placed their notes, select one artwork and read all the notes assigned to it. If the number of works and time permits, read aloud every note for every work.

5 After the notes have been read, what conclusions can you draw?

6 Let the artists have the written comments for their private reflections.

Space for notes:

IV. "Identifying your criteria"

1 Before a critique begins, write down 5–10 different criteria by which you would like to judge art. Write each criterion as one full but simple sentence. Use the format "a good work of art should . . . a good work of art should not . . ." Do not include more than one criterion in a single sentence. Here are some examples by college students from a variety of different classes using different media:

"A good work of art should cause a conversation."

"A good work of ceramics should function properly."

"A good work of art should be properly crafted."

"A good work of art leaves room for poetic interpretation."

2 Proof read your list of criteria. Check to see that you are using full sentences for each. Check for one-word criteria like "honesty" and make it into a full sentence. Be sure there is only one idea, one requirement per criterion, not "a good work of art should be properly crafted and honest."

3 Have everyone in the room read one of their criteria statements slowly and loudly. If the group is small, go around the room again and hear one more criterion from each participant.

4 Look over your list of criteria and select the one criterion you most believe.

5 Get up and closely examine the works to be critiqued.

6 Choose one work of art that best exemplifies your chosen criterion. Read your criterion out loud and then explain to the group why the artwork you have chosen best fits (or does not fit) your chosen criterion. Address the whole group, not the artist whose work you are critiquing.

7 Continue the process of taking a turn, reading your criterion aloud, and applying it to a chosen work.

Advanced discussion:

Do the exercise above and also critique the criteria offered by the whole group:

Which criteria do you want to hold onto? Why?

Are some criteria too vague to be useful?

Are any of the criteria too general to be useful?

Are some criteria useful for any artwork?

Which criteria are best for individual artforms?

Is the group's list missing any criteria that you think are important to include?

Space for notes:

V. "Ratings, reasons, and rules"

This critique[8] requires you to make a fully articulated judgment for a work of art by rating it, giving reasons for your rating, and providing a criterion that your reasons address.

1 Carefully view the selection of objects to be critiqued. Examine them closely.

[8] Based on the article by Mary Jane Aschner (1956), "Teaching the Anatomy of Criticism," *The School Review*, (64)7, 317–322.

2 As a group, agree on how many objects each of you will judge: all of them or a specific number of them depending on the size of the group, number of artists, and time allotted for the critique.

3 Have a separate piece of paper or notecards for each artwork that you judge. Write a rating for each one of the objects with a number from 1–10, with 10 being the highest.

4 Then write three reasons for each of your ratings. Use short full sentences, not single-word reasons.

5 Think about the reasons you provided and then write one general "rule" (criterion) for art: "A good work of art should. . ."

6 One by one, each person identifies the object they are judging and reads aloud their rating, reasons, and criterion. As a group, discuss the judgments as needed.

7 When the critique is finished, the artists take away the notecard comments about their works.

Space for notes:

VI. "A judgmental critique based on an artist's intent"

This critique is an exercise for understanding the roles of the artist's intention when judging their work. It asks first if the statement of intent is itself sensible and worth pursuing. Secondly, it examines whether the artwork and the verbal intent sufficiently match one another. A "bad" intent and a "good" artwork are not sufficient for this exercise, nor are a "good" intent but a "bad" artwork.

1 Before the critique begins, each artist writes a statement of intent about their artwork, in complete sentences, using this prompt: "I want my piece to express. . ."

2 The artist reads the intent slowly and loudly to the group. Ask the artist to read the intent twice, if necessary, for audibility. (It would be better if each participant had a copy of the written intent.)

3 The group of listeners then discusses the written statement of intent without talking to the artist and without matching the intent to the artwork. They ask and answer questions such as these: "Does the written intent make sense *in itself* apart from the artwork?" "Does the intent itself, apart from the artwork, express a valuable contribution or worthy goal for the artist or for society?" "Why or why not?" The artist listens and takes notes but does not join the discussion.

4 The group then critiques the artwork according to the artist's written intent answering questions like these:

"Do the words match what is seen in the work, suggested by the work, and sustained by the work?" "Does the work fulfill the written intention?" If "yes," say how. If the group finds significant differences between the written intent and the artwork, they answer these questions, "Is the artwork better than the intent? Different from the intent? Too limited by the intent?" If there is significant mismatch, "What might need to be changed: the statement, the work, or both?"

5 The artist merely listens, taking notes, and then later decides what if any changes to make to the artwork, the intent, or both.

Space for notes:

VII. "Me, the artist, the community"

Usually in critiques you are asked to judge particular examples of art works and determine if they are good as they are. You start with a particular poster, necklace, or painting and try to determine its merits. Usually you do not consciously generalize about all graphic communication or jewelry or painting, but stick with the one piece you are critiquing. This method of critique is very common and useful but it has limitations because the range of ideas is unnecessarily limited to the specific. Instead, you could begin with the general and answer the question of what is a good piece of jewelry, what makes an effective graphic communication, a successful painting.

1 Establishing ground rules. Are we going to accept this artwork as it is, or are we going to try to convince the maker to change it?

2 Start with the criterion or with the artwork itself. Is art good? Is this a good work of art? Could it be better?

3 Judge for yourself. Is it good for me? Why is it good for me? How is it good for me? Does it change my perspective? Does it give me joy or sadness or anxiety or? Does it show me something or teach me something? Does it ennoble my spirit?

4 Judge for the artist. What might this piece be doing for the artist? Does it look like a move forward or backward? Do I see risk taken by the artist? Does it seem to please

the artist? Might I have something to say that might encourage the artist?

5 Judge for the community. Would this piece be good for the community? Which community members would this work appeal to? Why would it be good? Would this piece be somehow detrimental to the community? How might it by? What might its effects be? If it would offend, who and why? If it would offend, is that a positive or a negative result? Why? Does this work benefit the world in some small way?

Space for notes:

VIII "Feminist criteria for judging art"

A feminist critique.

1 What feelings do you have about it? Why do you have those feelings?

2　What does the artwork say about women?

3　What does the artwork say about men?

4　What does the artwork say about race?

5　What does the artwork say about class, sexual orientation, age, ethnicity or other factors?

6　How has your identity influenced your view of the artwork?

7　How do you think the artist's identity influenced the artwork?

8　What kinds of ideas about life does the artwork prompt you to think about?

9　What does the artwork make you think about photography, about art, about artmaking and the art world?

10　Are there other kinds of information that may be particularly useful in understanding this artwork?

11　What kinds of information might this be and how might you find it? Should you try to?

12　What function does the artwork have in society?

13　What function does this artwork have for the artist?

14　Evaluate the artwork.

15　What are your criteria for judgment?
　　　(Anne Burkhart, The Ohio State University at Newark)

Space for notes:

IX "Formalist Criteria for Critiquing"

We sometimes use the following criteria when judging a work of art.

1 Repetition of shape, pattern. Repetition of shape is the taking of one idea, one theme or motif and consistently repeating its use. This allows for continuity in the work being produced.

2 Variation, gradation, contrast. These factors integrate to create continuity of low and movement.

 a) Variation is represented by a size change–small, medium, large.

 b) Graduation is represented by a color change–dark, medium, light.

 c) Contrast uses opposing elements to put "punch" into a composition.

3 Space, balance. It is the use of negative and positive space that allows a background to become an integral part of the foreground in a composition. It is the use of symmetry and asymmetry that achieves a feeling of completeness and balance, a harmonious play of various details.

4 Perspective, depth. It is another way to add interest or detail for viewing pleasure.

5 Focal point, emphasis. It is an area of emphasis (a *concentration* of detail) which allows the viewer's eye momentary rest and then visual flow or movement away. It focuses on the original of the directional movement of a composition.

6 Rhythm, flow, movement–The viewer's eye should travel from one part of the composition to another until the entire work has been seen.

7 Texture. It is another detail that adds richness and interest.

8 Color. It adds sensation, emotion, and feeling to a creation.

9 Your creative product is affected by: a) techniques, b) craftsmanship and quality of work, and c) form of overall work and it's the 2D or 3D qualities.

 (Sharon D. I. A. Pierre, Montana State University)

Space for notes:

More ideas for judgmental critiques

I like a forced-choice approach in which participants discuss two aspects of the object that work well and two aspects that do not. (Jerry Morris, Miami University, Ohio)

•

With beginning students, I sometimes use what I call "Three Pluses and a Wish." When students talk about the work of their peers, they have to say three ways the product meets the objectives of the assignment, and then they need to make a constructive comment about how they the wish the piece were different. (Debbie Smith-Shank, The Ohio State University)

•

Sometimes I have students take on the role of a judge or juror. I give them ballot forms and ask them to narrow down the number of works to be evaluated to eight. They openly discuss each of the works on display, and then vote. For a work to remain in, it must receive at least a third of the group's vote. When only eight remain, they then discuss the merits of the eight remaining pieces and each student fills out ballots covering Technique, Aesthetic Quality, and Personal Reaction to how the works achieved the goals of the assignment. These are rated on a 1–5 scale. We tally the ballots and announce the results. (James Brutger, Emeritus, University of Minnesota, Duluth)

•

To overcome the barrier of students not participating, I sometimes form small groups of students to critique one another's works without my being present. I often allow them to make changes to their works before the final critique at which I am present.

I have also used small groups to arrange a group of (anonymous) works from the most successful to least. The artists whose works are being discussed are not part of the discussion group. Some critiques end in peer grading or self-evaluation rather than relying only on my evaluation. (Ginna Sadler, Abilene Christian University)

•

Early in the Quarter I've been doing a "Criteria Critique." My idea for this came from a quick, in the hallway conversation with

SCAD Professor Stephen Gardner. In this critique I do not talk about the work being good or bad. Class projects are created with very specific criteria that must be met. Each aspect of the criteria can be met to varying degrees of success. Sometimes we will put up all the work and I will say, "OK, today we are going to only concentrate on work that meets all the criteria." We then slowly take down works that do not meet all the criteria. Once we arrive at the work that is to be discussed I tease apart all the aspects of the criteria and have students discuss how a particular project meets them. We often segue from one piece to the next by finding a connecting element, like picking a piece that they feel solves the criteria the exact way they did, then we discuss the two pieces. (Karen Sam Norgard, Savannah College of Art & Design)

7

Artist statements and biographies

If you continue pursuing art and design, you will inevitably be asked to write artist statements about your work. An "artist statement" consists of a brief narrative that you write about what you make, how you make it, when you made it, and why. Artist statements are usually required for applications to graduate schools and granting agencies, for entries into competitive exhibitions, to accompany exhibitions of your work in galleries, for online sales, and for personal web sites. Some occasions or purposes require an artist biography, which is different from an artist statement. Basically, an "artist biography" is a narrative version of your professional resume that informs the reader about your career credentials. Both statements and biographies are further examined in this chapter.

Books written by artists are often biographies that can also be read as extended artist statements. Books by two

photographers are examples. Edward Weston's *Day Books I & II*,[1] consist of diary entries over a fifteen-year period that he began in the 1920s. It is considered a classic of photographic literature. More recently, in 2015, Sally Mann wrote *Hold Still: A Memoir with Photographs*.[2] Books such as these are highly informative and can be very motivating. Our concerns here, however, are with shorter writings. Three short and succinct artist statements follow.

Exemplary artist statements

One contemporary painter posts artist statements about her work on a blog, "Holly Roberts One Painting at a Time."[3] For each blog entry, two a month, she offers a good quality reproduction of one of her paintings with its title and date, and one to three well written, straightforward explanatory paragraphs about that painting. An informative banner at the top of each posting says:

> 30+ years of painting, talked about one painting at a time: what went into the paintings, what I was trying to say, what was happening at the time of my life that I made the paintings.

[1] Weston E. & Newhall, N. (1973), *Edward Weston Day Books I & II*, New York: Aperture.

[2] Mann, S. *Hold Still: A Memoir with Photographs*, New York: Little Brown and Company, 2015.

[3] "Holly Roberts One Painting at a Time," http://hollyrobertsonepaintingatatime. blogspot.com (accessed 10 January 2018).

The paintings themselves are narrative, and this adds a little more to the story that they tell.[4]

Roberts usually writes about her paintings years after they were made, showing that artist statements can be written anytime and revised often. She offers answers to questions viewers might typically want to know about a painting. She wants her paintings to be read as visual narratives and helps viewers by offering some verbal information to compliment what they can see.

Similarly, Jackson Pollock offered this artist statement about his paintings and addressed questions that he likely knew viewers were asking about his work:

I want to express my feelings rather than illustrate them. It doesn't matter how the paint is put on, as long as something is said. On the floor I am more at ease. I feel nearer, more part of the painting, since this way I can walk around it, work from the four sides and literally be in the painting. When I'm painting, I'm not aware of what I'm doing. It's only after a get acquainted period that I see what I've been about. I've no fears about making changes for the painting has a life of its own.[5]

His first sentence is crucial and clear: He was not interested in making pictures of things or events, he wanted to express his

[4] Roberts, "Holly Roberts One Painting at a Time."
[5] Phillips, R. (2017), "Art and Artist's Statements by Famous Artists," Jackson Pollock, https://renee-phillips.com/art-and-artists-statements-by-famous-artists/ (accessed 9 June 2017).

feelings. He downplayed his method of painting, not mentioning the drips and splashes that were notorious. Instead he invites viewers to consider what might be said by the work but does not explain what he might have been trying to say: Even he, the maker, may discover much later what the painting may be about because meanings are not fixed and artworks have a life of their own.

Georgia O'Keeffe offered another example of a clear, succinct, and informative statement about her many paintings of flowers, which, in their bold simplicity, raised viewers' curiosities about why she made them:

> When you take a flower in your hand and really look at it, it's your world for the moment. I want to give that world to someone else... Nobody really sees a flower – really – it is so small – we haven't time – and to see takes time... So I said to myself – I'll paint what I see – what the flower is to me but I'll paint it big and they will be surprised into taking time to look at it.[6]

These three examples are of three very different kinds of paintings: narrative and symbolic, totally nonobjective, and representational. You can use these examples as models of what to write about and how to write it.

Louise Bourgeois provides a good example of an artist statement that is longer than one paragraph. The length of

[6] Phillips, R. (2017), Art and Artist's Statements by Famous Artists, "Georgia O'Keeffe."

statements varies but generally they are kept to one page. Bourgeois wrote this statement in 1954, early in her long career and it remains informative and insightful today:

My work grows from the duel between the isolated individual and the shared awareness of the group. At first I made single figures without any freedom at all: blind houses without any openings, any relation to the outside world. Later, tiny windows started to appear. And then I began to develop an interest in the relationship between two figures. The figures of this phase are turned in on themselves, but they try to be together even though they may not succeed in reaching each other.

Gradually the relations between the figures I made became freer and more subtle, and now I see my works as groups of objects relating to each other. Although ultimately each can and does stand alone, the figures can be grouped in various ways and fashions, and each time the tension of their relations makes for a different formal arrangement. For this reason the figures are placed in the ground the way people would place themselves in the street to talk to each other. And this is why they grow from a single point–a minimum base of immobility which suggests an always possible change.

In my most recent work these relations become clearer and more intimate. Now the single work has its own complex of parts, each of which is similar, yet different from the others. But there is still the feeling with which I began–the drama of one among many.

The look of my figures is abstract, and to the spectator they may not appear to be figures at all. They are the expression, in abstract terms, of emotions and states of awareness. Eighteenth-century painters made "conversation pieces"; my sculptures might be called "confrontation pieces."[7]

This last sample paragraph of an artist statement is an example of how <u>not</u> to write one. A writer and curator wrote the paragraph as an intentionally bad example of an artist statement. He rightly calls this kind of writing "pompous," "rambling," and "preposterously complex":

Combining radical notions of performativity and the body as liminal space, my practice interrogates the theoretical limitations of altermodernism. My work, which traverses disparate realms of object-making such as painting and performance, investigates the space between metabolism and metaphysics and the aporia inherent to such a discourse.[8]

He opposes this kind of writing because he thinks it is "a dialect of the privileged" that fosters a "growing boundary between the art world and the rest of society."[9]

[7] Artist Statements An Archive (2017), "Louise Bourgeois," https://artiststatements.wordpress.com (accessed 14 June 2017).

[8] Blight, D. (2013), "Writing an Artist Statement? First Ask Yourself These Four Questions," https://www.theguardian.com/culture-professionals-network/culture-professionals-blog/2013/apr/15/writing-artist-statement-tips-language (accessed 14 June 2017).

[9] Blight, "Writing an Artist Statement."

An exemplary artist biography

The following artist biography of Kara Walker is offered on a webpage for Art21 whose self-stated mission is to present "thought-provoking and sophisticated content about contemporary art" in order to "inspire a more creative world through the works and words of contemporary artists."[10] Before moving on, note how clearly and informatively Art21 articulates their mission statement. Their mission statement is their artist statement. It states what they do (inform about contemporary art), how they do it (with thought-provoking and sophisticated content), and why (to inspire a more creative world through artworks and words). The biography is written to accompany a web-based and video-based presentation of the artist's work around the year 2000:

> Kara Walker was born in Stockton, California, in 1969. She received a BFA from the Atlanta College of Art in 1991, and an MFA from the Rhode Island School of Design in 1994. The artist is best known for exploring the raw intersection of race, gender, and sexuality through her iconic, silhouetted figures. Walker unleashes the traditionally proper Victorian medium of the silhouette directly onto the walls of the gallery, creating a theatrical space in which her unruly cut-paper characters fornicate and inflict violence on one another.

[10] Art21, https://art21.org (accessed January 10, 2018).

In works like *Darkytown Rebellion* (2000), the artist uses overhead projectors to throw colored light onto the ceiling, walls, and floor of the exhibition space; the lights cast a shadow of the viewer's body onto the walls, where it mingles with Walker's black-paper figures and landscapes. With one foot in the historical realism of slavery and the other in the fantastical space of the romance novel, Walker's nightmarish fictions simultaneously seduce and implicate the audience.

Walker's work has been exhibited at the Museum of Modern Art, New York; San Francisco Museum of Modern Art; Solomon R. Guggenheim Museum, New York; and Whitney Museum of American Art, New York. A 1997 recipient of the MacArthur Fellowship, Walker was the United States representative to the 2002 Bienal de São Paulo. Walker currently lives in New York, where she is on the faculty of the MFA program at Columbia University.[11]

Walker's biography is three paragraphs and only 235 words. It is written in third person, as if someone other than Walker has written it about her. The first paragraph provides facts of Walker's life: year and place of her birth and degrees that she has earned. It packs a lot of information about her content and style, which portrays "the raw intersection of race, gender, and sexuality." She makes "unruly" characters of cut-paper that "fornicate and inflict violence on one another."[12]

[11] Art 21 (2017), "Kara Walker," https://art21.org/artist/kara-walker/ (accessed 17 August 2017).

[12] Art 21: "Kara Walker."

The second paragraph refers to a specific example, *Darkytown Rebellion*, from the whole of her work, and by means of the example provides information about her subject matter, style, technique, and their implications. She deals with slavery in a historically real sense but also in a way that references romance novels. She uses overhead projectors for lighting in a way that makes the viewers of the piece part of the piece: The viewers' silhouettes are on the gallery walls along with Walker's cut out silhouettes. This technique seductively draws viewers into the work and also implicates them in the social injustice of slavery.

The third paragraph offers a straightforward listing of her artworld credentials, including her faculty position in the MFA program of Columbia University. She lives in New York.

This and any biography both include and exclude information. Walker's biography explicitly reveals that the artist is female by the use of the feminine pronoun "she" in the first paragraph and after that reference refers in a gender-neutral way to "the artist." The biography does not refer to her race: Although she is African American, she is not identified as such in the biography nor is she referred to as a "black artist" or a "black woman artist." Nor does the biography include information about her marital status or her daughter. Presumably the artist and author do not consider these sufficiently relevant to include in her artist biography. The decision to omit race, however, is more consequential, especially given that the work is said to be racially "raw" and uses a term such as "Darkytown" in the title of an installation. Walker may or may not have written the biography

quoted here but as an artist of prominence, she likely has editorial control of what will be included and excluded in her biography. As an artist who will be writing your own biography, you will be deciding what you will include and exclude about yourself and your work. Consider implications or questions your biography might raise.

Suggestions for writing artist statements and biographies

Topics for your artist biography

The Maryland Institute College of Art helpfully clarifies the difference between an artist biography and an artist statement this way: "In general, bios are more factual about you as an artist, whereas statements are more about the ideas, concepts, and techniques behind your work."[13] Your artist biography parallels your vita or resume but is written in narrative form. You can use it in a portfolio packet, cover letter, or on your website. It informs prospective gallery owners, curators, granting agencies, and buyers about who you are and why they may want to support your work.

In your biography, describe your current work and identify its content and medium. Include your education in art, recent

[13] Maryland Institute of College of Art (2017), "Developing Artist Statements and Artist Bios," https://www.mica.edu/Documents/Career%20Services/ArtistStatementBio11.pdf (accessed 21 June 2017).

and historical influences, and what else affects your artistic efforts. Include exhibits you have been in with the names of curators and jurors, if applicable, and collections that contain your work, commissions, and awards if you have received some. State where you were born and where you live now. Your biography should remain as fluid as your life, with pertinent updates as they occur. One or two pages in length are sufficient.

Be careful with language

ArtBusiness.com advises a general tone and spirit for writing either an artist statement or biography:

> Just about all artists want as many people as possible to appreciate their art. A good artist statement works towards this end, and the most important ingredient of a good statement is its language. Write your statement in language that anyone can understand, not language that you understand, not language that you and your friends understand, not language that you learn in art school, but everyday language that you use with everyday people to accomplish everyday things. An effective statement reaches out and welcomes people to your art, no matter how little or how much they know about art to begin with; it never excludes.[14]

[14] ArtBusiness.com (2017), "Your Artist Statement: Explaining the Unexplainable," http://www.artbusiness.com/artstate.html (accessed 20 June 2017).

Choose a first person, second person, or third person point-of-view

Artist statements are usually written in the first person ("My work is ..." "I make ..."); artist biographies are usually written in the third person, ("She makes unruly characters ..."); and the use of second person is generally avoided ("You will ..."). As the author of your text, you can choose to be an "I," a "she" or a "he." Writing as "I" rather than "she" or "he" gives your statement a sense of immediacy, honesty, and clarity. You can say what your art does for you, rather than what it is supposed to do for your readers. You likely will not begin every sentence with "I," but avoiding use of "you" leaves room for readers to respond to your work in their own ways without you telling them how or what to think. Your use of "she" or "he" to refer to yourself may cause wonder about who is writing about you, why, and if they are a reliable source. If you wish to be gender neutral, you can use "the artist."

Identify what you make and how you make it

In either your artist statement or biography, briefly identify the kind of things that you make: "My paintings are narrative," or "she makes silhouettes of black-paper figures and landscapes." Include something about the process of how you make your art. Perhaps tell how you begin a piece: is it well thought out before you begin making marks or forming three-dimensional shapes:

Do you begin with an idea and then try to visualize it or do you start with subject matter that attracts you? What are you likely not to do in your work?

Indicate what your work is about

Perhaps think of your statement or biography as a door through which people can enter your expressive world. You need not tell them everything but give them some help to get into the spaces you want them to explore.

The following statement about Walker's art sets the topic and then invites the viewer to figure out what might be revealed through the artist's exploration without having told them what to think: "The artist is best known for exploring the raw intersection of race, gender, and sexuality through her iconic, silhouetted figures." The statement identifies the themes of her work but by not including too much more, the sentence should arouse enough viewer curiosity to draw viewers in to see the work itself.

By writing "I want to express my feelings rather than illustrate them," Pollock reveals that his work is about feelings but does not tell us what his feelings were or how we should feel when seeing his paintings. He made the work, he lets us decipher it further, and he gives us a good starting point to do so. O'Keeffe writes that "I'll paint what I see – what the flower is to me but I'll paint it big and they will be surprised into taking time to look at it." She lets us find our own surprises.

Articulate why you make art

Consider telling your viewers what motivates you to make what you make. What are you trying to contribute to the world with your work? With her flower paintings, O'Keeffe wants to show how to look more closely, attentively, and appreciatively at the world. More personally and uniquely, consider telling what keeps you going back into your studio day after day to face success and failure, joy and frustration.

Imagine an ideal viewer of your work. List the aspects of your work that they would notice and appreciate. Try being the viewer of your work. Tell us what you like and cherish most about it.

Who do you make your art for?

In the statements she makes about her art, and in the information that her artist biography provides, Walker indicates that her work may not be what everyone wants to look at: Since she is best known for exploring the raw intersection of race, gender, and sexuality, a viewer may not want to explore these topics in the ways that she approaches them. It's a fair warning. Similarly, Pollock says that if you want illustrations, you will not find them in his work, and without dismissing it, suggests that you might go elsewhere for that kind of art. Who do you most want to reach with your work?

Anticipate the viewer and reader you are writing for

When you write about your work, carefully consider whom you are writing for. Maybe you provide the same information in the same way no matter who might read it. However, you might consider how to write differently about the same work that will be seen in different venues: if your known audience is the selections and admissions committee of a graduate school of art, you might write differently than for an exhibition in the student union where viewers with many different past experiences and expectations about art will see your work. It is not that you would be phony; it is that you would craft your writing so as to better communicate to and connect with different audiences.

Editing suggestions

One basic purpose in writing a statement or biography is to show that you can write. Carefully proofread and then edit everything you write before you release it. Reading what you have written out loud to yourself, you may more easily find errors. You will be better able to find errors if you print out your writing rather than proofing it on a screen.

Follow the advice of Strunk and White and eliminate unnecessary words: "Vigorous writing is concise. A sentence should contain no unnecessary words, a paragraph no unnecessary sentences, for the same reason that a drawing should have no unnecessary lines and a machine no unnecessary parts."[15]

Generally use active voice and avoid passive voice. The use of active voice clarifies your meaning and keeps sentences from becoming too complicated. Active voice is more direct, forceful, and clearer in meaning than passive voice. The use of passive voice in this sentence raises but does not answer the question of who initiated a new style. Instead of writing "A new style of sculpting was initiated," write in active voice for clarity and precision: "Minimalist sculptors initiated a new style of sculpting." Generally avoid using passive voice: "The paint was splashed on by him," and instead use active voice: "He splashed the paint on the canvas."

Tips for non-native speakers

If English is not your most proficient language, consider this advice about writing in English from a professional gallery:

> Write your statement in your native language first, and then translate it. You can use a professional translator, or you can try to translate it with an application online. Just be sure that you have it double-checked by a native speaker of whatever language your statement will be published in before you submit.[16]

[15] Strunk W. Jr. & White E. B. (2000), *The Elements of Style*, 4th ed., Longman Publishing Group.

[16] Agora Gallery, "How To Write An Artist Statement: Tips From The Art Experts," http://www.agora-gallery.com/advice/blog/2016/07/23/how-to-write-artist-statement/ (accessed 20 June 2017).

Get second opinions

Obtain reactions from others of different backgrounds and then adjust your statement further, if necessary:

> Before sharing your artist statement with the public, have friends give you feedback. Ask them if it makes sense. Also, ask them what they feel and see when they view your art. They might have a different perspective that makes you see your art in a new light. And what delights and engages one person, will probably interest others as well. You can use these discoveries to add to your artist statement.[17]

Selectively show your artist statement or biography to friends or classmates before you publish it. Ask them first to read your statement by itself, without seeing the work, and ask for their reactions: "Does this statement make sense in itself without seeing my work? Does it move you to want to see the work? If not, how might I better write this?" Then show them the work and ask them to consider the statement again and ask: "Does the statement fit the work that you see here? If not, how might I adjust the statement to make it better correspond to what you see and experience when looking at my work?"

[17] Agora Gallery.

Concluding remarks

Writing your biography and artist statement provides you reflective time to consider what you are doing as an artist or designer, why, how, and ways to communicate to larger audiences who you are and what you are about. Engaging in the process of writing about your work hopefully provides you with a better understanding of art, yourself, and how you want to exist as a creative and contributing person in the world. Such understandings of art and self are further awakened and prompted through thought and talk about your work with others in situations such as critiques, either formal critiques called for by an instructor, or informal critiques that you facilitate among people of your choosing. You will certainly need to work alone but you will also likely benefit from a supportive community of your own finding and fashioning.

References

Abrams, M. H. (1971). *The Mirror and the Lamp: Romantic Theory and the Critical Tradition*. NY: Oxford.

Agora Gallery, "How To Write An Artist Statement: Tips From The Art Experts," http://www.agora-gallery.com/advice/blog/2016/07/23/how-to-write-artist-statement/ (accessed 20 June 2017).

ArtBusiness.com (2017), "Your Artist Statement: Explaining the Unexplainable," http://www.artbusiness.com/artstate.html (accessed 20 June 2017).

Artist Statements: An Archive (2017), https://artiststatements.wordpress.com (accessed 14 June 2017).

Art 21 (2017), "Kara Walker," https://art21.org/artist/kara-walker/ (accessed 17 August 2017).

Aschner, M. A. (1956), "Teaching the Anatomy of Criticism," *The School Review*, (64)7, 317–322.

Barrett, T. (1988). "A Comparison of The Goals of Studio Professors Conducting Critiques and Art Education Goals for Teaching Criticism," *Studies in Art Education*, (30)1, 22–27.

Barrett, T. (1997). *Talking About Student Art*. Worcester, MA: Davis Publications.

Barrett, T. (2000). "Studio Critiques in College Art Courses as They Are and as They Could Be with Mentoring," *TIP: Theory into Practice*, (39)1, 29–35.

Barrett, T. (2000). "About Art Interpretation for Art Education," *Studies in Art Education*, (42)1, 5–19.

Barrett, T. (2003). *Interpreting Art: Reflecting, Wondering, and Responding*. New York: McGraw-Hill.

Barrett, T. (2003). "Interpreting Visual Culture," *Journal of Art Education*, (56)2, 6–12.

Barrett, T. (2004). "Improving Student Dialogue About Art," *Teaching Artist Journal*, (2)2, 87–94.

Barrett, T. (2010), *Making Art: Form & Meaning*. New York: McGraw-Hill.

Barrett, T. (2011). *Criticizing Art: Understanding the Contemporary*, 3rd ed., New York: McGraw-Hill.

Barrett, T. (2011). *Criticizing Photographs: An Introduction to Understanding Images*, 5th ed., New York: McGraw-Hill.

Barrett, T. (2017). *Why Is That Art?: Aesthetics and Criticism of Contemporary Art*, 3rd ed., New York: Oxford University Press.

Beardsley, M. & Wimsatt, W. (1946). "The Intentional Fallacy," *The Sewanee Review*, (54)3, 468–488, https://american-poetry-and-the-self12. wikispaces.com/file/view/Wimsatt+%26+Beardsley,+Intentional+ Fallacy.pdf (accessed 9 January 2018).

Blight, D. (2013), "Writing an Artist Statement? First Ask Yourself These Four Questions," April 15, 2013, https://www.theguardian.com/ culture-professionals-network/culture-professionals-blog/2013/ apr/15/writing-artist-statement-tips-language (accessed 14 June 2017).

Burkhart, A. (1997). "A Feminist-Based Studio Art Critique: A Classroom Study," *Marilyn Zurmuehlin Working Papers in Art Education*, 42–54.

Community Tool Box, "Techniques for Leading Group Discussions," University of Kansas, http://ctb.ku.edu/en/table-of-contents/leadership/ group-facilitation/group-discussions/main (accessed 24 May 2017).

Eco, U. (1992). *Interpretation and Overinterpretation*. Cambridge, England: Cambridge University Press.

English Oxford Living Dictionaries (2017) https://en.oxforddictionaries. com/definition/critique (accessed 18 July 2017).

Feldman, E. B. (1993), *Practical Art Criticism*, Englewood Cliffs, NJ: Prentice Hall.

Griffin, K. (2016). "MashUp looks at how a gesture in the studio in the early 20th century influenced today's visual and aural culture," http:// vancouversun.com/news/staff-blogs/mashup-looks-at-how-a-simple- gesture-in-the-studio-influenced-todays-visual-and-aural-culture (accessed 12 December 2017).

Gude, O. (2004), "Postmodern Principles: In Search of a 21st Century Art Education," *Art Education*, (57)1, 6–64.

Hirsch, E. D. (1973). *Validity in Interpretation*, New Haven, CT: Yale University Press.

Jane, J. (2017), 5 NYC Art Blogs You Should Be Reading, Huff Post, https://www.huffingtonpost.com/2013/09/26/nyc-art-bloggers–5-blogs-_n_3997011.html (accessed 28 December 2017).

Mann S. (2015), *Hold Still: A Memoir with Photographs*, New York: Little Brown and Company.

Maryland Institute of College of Art, "Developing Artist Statements and Artist Bios," https://www.mica.edu/Documents/Career%20Services/ArtistStatementBio11.pdf (accessed 21 June 2017).

Merriam-Webster, "Plagiarism," http://www.learnersdictionary.com/definition/plagiarism (accessed 10 December 2017).

Phillips, R. (2016), "Art and Artist's Statements by Famous Artists," https://renee-phillips.com/art-and-artists-statements-by-famous-artists/U (accessed 9 June 2017).

Plunkett, J. (2017), Justin Plunkett, http://www.justinplunkett.com (accessed 28 August 2017).

Roberts, H. (2016), "Holly Roberts One Painting at a Time," http://hollyrobertsonepaintingatatime.blogspot.com (accessed 11 June 2017).

Strunk, W. Jr. & White E. B. (2000), *The Elements of Style*, 4th ed., Longman Publishing Group, 2000.

Szarkowski, J. (1978). *Mirrors and Windows: American Photography since 1960*. NY: Museum of Modern Art.

The Met, "After Walker Evans: 4," https://www.metmuseum.org/art/collection/search/267214 (accessed 10 December 2017).

Tippett, K. (2017), *On Being*, Marie Howe, "The Power of Words to Save Us," https://onbeing.org/programs/marie-howe-the-power-of-words-to-save-us-may2017/ (accessed 24 August 2017).

Weston E. and Newhall, N. (1973), *Edward Weston Day Books I & II*, New York: Aperture, 1973.

Weston E. and Newhall N. (1973), Edward Weston *Day Books I & II*, New York: Aperture.

Work Group for Community Health and Development, http://communityhealth.ku.edu (accessed 17 June 2017).

178 References

Yalom, I. D. (2005), *The Theory and Practice of Group Psychotherapy*. 5th ed., New York: Basic Books.

Yalom, I. D. (2015), *Creatures of a Day: And Other Tales of Psychotherapy* New York: Basic Books.

Index